T0294039

cinco
años después

[VIDAS MINADAS]

five years later

Dirección editorial *Editorial Director*

Leopoldo Blume
Gervasio Sánchez

Fotografías y textos *Photographs and text*

Gervasio Sánchez

Traducción *Translation*

Angela Reynolds

Positivado de las fotografías *Photo Processing*

Juan Manuel Castro Prieto

Diseño y maquetación *Design and Layout*

Natàlia Arranz

Coordinación *Production*

Cristina Rodríguez Fischer

Fotomecánica *Typesetting and colour reproduction*

Scan 4, Barcelona

Impresión *Printed by*

Plan B Barcelona Press

Primera edición 2002 *First edition 2002*

© 2002 Art Blume, S.L.
Av. Mare de Déu de Lorda, 20
08034 Barcelona
Tel. 93 205 40 00
Fax 93 205 14 41
E-mail: info@blume.net

© 2002 Gervasio Sánchez
© 2002 de los textos, sus autores *© 2002 for the text, the authors*

ISBN: 84-95939-33-9
Depósito legal *Legal Deposit* B-31.528-2002
Impreso en España *Printed in Spain*

Todos los derechos reservados. Queda prohibida la reproducción total
o parcial de esta obra, sea por medios mecánicos o electrónicos, sin la
debida autorización por escrito del editor.
All rights reserved. No part of this publication may be reproduced,
stored in a retrieval system or transmited, in any form or by any
means, without prior written permission from the publishers.

Consulte el catálogo de publicaciones on-line,
Internet: http://www.blume.net
See our catalogue on-line
Internet: http://www.blume.net

cinco
años después

[VIDAS MINADAS]

five years later

GERVASIO SÁNCHEZ

Intermón
Oxfam

MEDICOS
SIN FRONTERAS

BLUME

El Tratado de Ottawa, cinco años después

El 3 de diciembre de 1997, 122 Estados firmaron en Ottawa la «Convención sobre Prohibición, Uso, Almacenaje, Producción y Comercialización de Minas Antipersona y su Destrucción», conocida como el Tratado de Ottawa. Pero todavía hoy, cinco años más tarde, millones de personas conviven con la amenaza diaria de las minas y cada día se producen nuevas víctimas en el mundo.

En líneas generales, se ha avanzado desde la firma del Tratado en la destrucción de minas y ha decrecido su uso y producción en los últimos años. Las 26.000 nuevas víctimas que se registraban anualmente en la década de los noventa han menguado en los tres últimos años hasta la cifra de 15.000 a 20.000 personas, como consecuencia principalmente de los programas de desminado y de un menor uso. Reducciones importantes en el número de nuevas víctimas se registraron en el año 2000 en zonas muy minadas de Afganistán, Camboya, Croacia y Kosovo.

Otras pruebas de los avances son la reducción del número de países productores de minas de 55 a 14 y la destrucción de 27 millones de minas antipersona por parte de 50 Estados. Según el Tratado, todos los Estados que lo han firmado y ratificado están obligados a destruir los arsenales durante los cuatro años siguientes a su ratificación. Esta fecha está próxima para muchos países y será un momento clave para valorar la voluntad política real de los diferentes países para llevar a cabo la destrucción total de las minas, única garantía de futuro.

La Campaña Internacional para la Prohibición de las Minas Antipersona (International Campaign to Ban Landmines, ICBL), que agrupa a más de mil organizaciones de todo el mundo y que fue la principal impulsora de la firma de la Convención, sigue de cerca la aplicación del Tratado y publica periódicamente informes sobre la actuación y compromiso de los diferentes gobiernos. El intenso trabajo de la ICBL desde 1992 la hizo merecedora del Premio Nobel de la Paz 1997.

Las minas siguen cobrándose muchas víctimas

Sin embargo, y a pesar de estos avances, en los años 2000 y 2001, las decenas de millones de minas que siguen enterradas en el mundo causaron nuevas muertes y mutilaciones en 73 países. 45 de estos países no estaban en guerra.

Las minas son actualmente uno de los principales problemas en países como Afganistán, Bosnia, Camboya, Chechenia, Irak, Mozambique, Nicaragua o Somalia, ya que no distinguen entre la pisada de un niño y la de un soldado, no escuchan Tratados de Paz y continúan hiriendo y matando muchos años después de que el conflicto haya terminado. Sólo en Camboya, por ejemplo, hay más de 35.000 personas que han sufrido amputaciones como consecuencia de las minas. Sin contar las miles de personas que han muerto.

Además, las minas dejan inservibles grandes extensiones de tierra, lo que impide a miles de familias cultivar el campo, y suponen una grave amenaza para las personas refugiadas y desplazadas que intentan regresar a sus casas una vez ha finalizado el conflicto.

The Ottawa Convention, five years later

On 3rd December 1997 in Ottawa, 122 countries signed the "Convention on the Prohibition of the Use, Stockpiling, Production and Transfer of Anti-personnel Mines and on their Destruction" , known as the Ottawa Convention. But today, five years later, there are still millions of people who live with the daily threat of anti-personnel mines and every day there are new victims around the world.

In general terms, there has been progress since the Convention was signed on the destruction of mines, and their use and production has dropped in the past few years. The 26,000 new victims registered annually in the nineties have dropped in the past three years to between 15,000 and 20,000 people, mainly as a result of the programmes to clear the mines and because of lower deployment. In the year 2000, there were important reductions in the number of victims in highly-mined areas such as Afghanistan, Cambodia, Croatia and Kosovo.

More proofs of progress are the reduction of the number of countries which manufacturate these mines, from 55 to 14, and also the destruction of 27 million anti-personnel mines in 50 countries. According to the Convention, all the States Parties, those countries who have signed and ratified the Convention, should destroy their stockpiles in the four years following ratification. This date is coming due in many countries and it will be a key moment to evaluate the real political interest of the different countries in carrying out the total destruction of anti-personnel mines, the only way to guarantee the future.

The International Campaign to Ban Landmines, (ICBL), grouping together over one thousand organisations worldwide was the main force behind the signing of the Convention. It closely monitors the application of the Convention and publishes regular reports about the different governments' acts and committment. The intense work carried out by ICBL since 1992 was rewarded with the Nobel Peace Prize in 1997.

The mines still cause many victims

However, despite these advances, during the years 2000 and 2001, the tens of millions of mines still buried worldwide maimed and killed people in 73 countries. Most of these countries, a total of 45, were not at war.

The mines are currently one of the main problems in countries such as Afghanistan, Bosnia, Cambodia, Chechnya, Iraq, Mozambique, Nicaragua or Somalia, since they do not make a distinction between the footstep of a child and a soldier, they do not listen to Peace Treaties and they continue to maim and kill many years after the war has ended. For example, in Cambodia alone there are over 35,000 people who have had limbs amputated as a result of the mines, without counting the thousands of people who have died as a consequence.

What's more, the mines make huge areas of land unusable, preventing thousands of families from cultivating the fields, and they are a grave danger to the refugees and displaced people who try to return to their homes after a war has finished.

Aún mucho por hacer

Desde 1993, ya antes de la firma del Tratado, muchos países donantes han contribuido al desminado con más de 1.000 millones de dólares, lo que ha permitido desminar grandes áreas de países gravemente afectados como Afganistán, Angola, Bosnia, Camboya, Croacia, Kosovo, Laos y Mozambique.

Sin embargo, los fondos dedicados son claramente insuficientes para atender las necesidades de desminado y para socorrer a las víctimas, dos puntos clave del Tratado. Además, en los últimos años algunas operaciones de desminado han tenido que ser suspendidas antes de finalizar por la falta de financiación. Estas interrupciones dejan sin valor a los programas, puesto que una zona que no esté completamente desminada es igual de insegura y peligrosa que una en la que queden sólo la mitad de las minas.

Las ONG reclaman desde hace años a los gobiernos que dediquen un 1 % de sus presupuestos de defensa a proyectos contra las minas. Si se tiene en cuenta que, entre 1988 y 1998, la media anual de gasto en defensa en el mundo fue de 74 billones de dólares, el 1 % representaría unos 740 millones de dólares anuales. Si la comunidad internacional se comprometiera a dar un apoyo similar, bastaría con unos cuantos años, y no décadas, para atender las necesidades de desminado y atención a las víctimas en el mundo.

En el caso de España, las ONG exigen al Gobierno que destine una partida de 6 millones de euros anuales a programas de desminado y asistencia a las víctimas, lo que representaría tan sólo el 1,6 % de las ventas españolas anuales de armas. Hasta la fecha, la contribución de España a la acción contra las minas ha sido escasa, con un promedio de 700.000 euros anuales para el período 1995-2001.

Estados Unidos, China y Rusia, los grandes ausentes del Tratado

El Tratado de Ottawa se firmó en diciembre de 1997 y entró en vigor el 1 de marzo de 1999. En septiembre de 2002, 143 países lo habían firmado, de los cuales 125 lo habían ratificado. España firmó el Tratado en diciembre de 1997 y lo ratificó en enero de 1999.

Sin embargo, existen 50 países en el mundo que no lo han firmado, hecho que imposibilita universalizar la prohibición de las minas y que pone en peligro la efectividad del Tratado. Entre estos países se encuentran Estados Unidos, China y Rusia, principales productores y exportadores de minas antipersona.

Además, el hecho que estos países no hayan firmado el Tratado supone otro problema añadido ya que puede darse el caso de que países que sí han firmado el Tratado participen en operaciones militares conjuntas con otros países que no lo han firmado, operaciones en las que las minas se utilizan de forma indiscriminada como arma de guerra. Es el caso, por ejemplo, de la intervención militar de la OTAN en Afganistán, como respuesta a los atentados del 11 de septiembre en Estados Unidos. Los Estados signatarios del Tratado deben ser coherentes con su posición y negarse a participar en este tipo de operaciones conjuntas en las que se utilizan minas o presionar para que éstas no se empleen.

Pero éste no es sólo un problema limitado a las operaciones de la OTAN. Existen dudas también sobre la posición de Tajikistán, firmante del Tratado, respecto al

Still so much to do

Since 1993, even before the signing of the Convention, many donor countries have contributed to the destruction of mines with over 1,000 million dollars, funding the clearance of mines from large areas in severely affected countries such as Afghanistan, Angola, Bosnia, Cambodia, Croatia, Kosovo, Laos and Mozambique.

Nonethless, the funds destined to this end are clearly insufficient to cover the requirements for the total destruction of mines and to assist the victims, two key points in the Convention. Also, in the past few years, some mine-clearance programmes have had to be suspended before being completed, due to lack of funds. These interruptions make the programmes almost worthless, since an area which has not been totally cleared of mines is just as unsafe and dangerous as one where half the mines are still buried.

For many years now, NGOs have demanded that governments use 1% of their defence budgets to finance projects for the destruction of mines. Taking into account the fact that, between 1988 and 1998, the average annual defence budget worldwide was 74 billion dollars, 1% would be around 740 million dollars a year. If the international community pledged to give a similar level of support, it would only take a few years, and not decades, to complete the clearance and destruction of all mines and to assist the victims worldwide.

In the case of Spain, the NGOs are demanding that the government sets an annual budget of 6 million euros for mine-clearance programmes and assistance for the victims, which would amount to just 1.6% of the annual sales of Spanish weaponry. To date, Spain's contribution to the anti-mine programmes has been meagre, with an average of 700,000 euros a year, for the period 1995-2001.

The United States, China and Russia, the powers not in the Convention

The Ottawa Convention was signed in December 1997 and came into effect on 1st March 1999. By September 2002, 142 countries had signed, of which 125 had also ratified it. Spain signed the Convention in December 1997 and ratified it in January 1999.

There are, however, 50 countries in the world that have not signed, making a universal ban on mines impossible to implement and endangering the effectiveness of the Convention. Among these countries are the United States of America, China and Russia, the leading manufacturers and exporters of anti-personnel mines.

The fact that these countries have not signed the Convention also gives rise to another problem, since countries which have signed the Convention could find themselves involved in joint military operations with those who have not signed, and where mines are used indiscriminately as a war weapon. This is the case, for example, of the NATO military interventions in Afghanistan, carried out as a reprisal for the attacks of 11th September 2001 in the USA. The States Parties to the Convention should maintain a coherent position and refuse to take part in this type of joint operation where mines are used, or exert pressure to prevent mines being deployed.

uso de minas antipersona de las fuerzas rusas estacionadas en su territorio. También algunos estados africanos firmantes del Tratado han participado o apoyado operaciones militares en las que se ha hecho uso de minas antipersona. Esto incluiría Namibia, en la guerra de Angola contra la guerrilla de UNITA, así como Uganda, Ruanda y Zimbabue con varias fuerzas dentro de la República Democrática del Congo. Como Estados firmantes del Tratado, estos países deberían manifestar categóricamente su negativa a participar en operaciones conjuntas con fuerzas militares que utilicen minas antipersona.

Falta de dureza contra los países que utilizan minas

Desde la campaña internacional ICBL se ha invitado en reiteradas ocasiones a los Estados parte a condenar en voz alta y de forma constante a los que eligen permanecer fuera del Tratado y siguen haciendo uso de las minas. En la práctica, sin embargo, se han tomado muy pocas medidas concretas para penalizar a los países que aún utilizan minas. En su informe de 2001, la ICBL confirmaba el uso de minas antipersona en 23 conflictos por parte de 15 gobiernos y más de 30 grupos rebeldes. Esta cifra es muy preocupante teniendo en cuenta que supone un incremento respecto a los datos de años anteriores.

Pero no sólo los países no firmantes suponen una amenaza. La Campaña ha denunciado en varias ocasiones a algunos de los estados firmantes del Tratado por seguir utilizando las minas en la actualidad. Estos países no sólo hacen una burla de su supuesto compromiso, sino que violan el derecho internacional humanitario. Es el caso, por ejemplo, de Angola, que ha admitido públi-

camente el uso continuado de las minas en sus operaciones militares contra el grupo rebelde UNITA. Y sería el caso también, según los informes de la ICBL, de Sudán, Etiopía, Ruanda y Burundi, si bien sus gobiernos siempre lo han negado.

Durante estos años de vigencia del Tratado, se ha hecho cada vez más evidente la necesidad de involucrar en este proceso a los actores no estatales. En septiembre de 2001, el Parlamento Europeo aprobó una resolución en este sentido pidiendo a la comunidad internacional la búsqueda de un compromiso de todas las partes en conflicto, Estados y no estados, para prohibir totalmente el uso de las minas.

No hay duda de que el Tratado sobre Prohibición de Minas Antipersona ha supuesto un punto de partida más que acertado y que, en líneas generales, la tendencia positiva continúa. En años recientes se ha producido la destrucción extensa de minas almacenadas, ha aumentado la financiación para los programas de desminado y se han limpiado consecuentemente más hectáreas de tierra, disminuyendo así el número de nuevas víctimas.

Sin embargo, quedan aún muchos pasos que dar. La manera en la que se siga avanzando en los próximos años es crucial para la credibilidad y efectividad del Tratado. Es importante que todos, gobiernos, organizaciones internacionales y ONG, continuemos nuestra lucha contra lo que desde hace años venimos denunciando como un arma del terror que aún hoy en día utilizan gobiernos y grupos rebeldes en algunos países del mundo, sin ser penalizados por ello.

But this problem is not limited to NATO operations. There are also doubts about the position of Tajikistan, party to the Convention, with regard to the use of anti-personnel mines by the Russian army units stationed in that territory. There are also several African countries who have signed the Convention that have taken part in or supported military operations where anti-personnel mines have been deployed. These include Namibia, in the war against UNITA guerrilla in Angola, as well as Uganda, Ruanda and Zimbabwe with various forces within the Democratic Republic of the Congo. As countries which have signed the Convention, they should categorically state that they will not take part in joint operations with any military force that uses anti-personnel mines.

Lack of strength against countries that use mines

Since ICBL's international campaign, the States Parties have been repeatedly invited to condemn, out loud and constantly, those that elect to remain outside the Convention and continue to use mines. In practice, however, there have been very few concrete measures taken to punish countries that still use mines. In its report for 2001, ICBL confirmed the use of anti-personnel mines in 23 conflicts, by 15 governments and over 30 rebel groups. These figures show a worrying increase over the data for previous years.

But not only the countries who have not signed the Convention are a threat. The Campaign has denounced some of the countries that have signed the Convention on several occasions for continuing to use mines even now. These countries have not only turned their supposed committment into a cruel joke, but are in violation of international human rights. This is the case, for example, of Angola, which has publicly admitted the continued deployment of mines in its military operations against the UNITA rebel forces. And there are similar cases, according to the ICBL report, in Sudan, Ethiopia, Ruanda and Burundi, although their governments have always denied this.

In the years that the Convention has been in effect, the need to involve non-governmental parties has become ever more apparent. In September 2001, the European Parliament passed a resolution to this effect, requesting the international community to work for the commitment of all parties in conflict, states and non-states, to bring about a total ban of use of mines.

The Convention on the Prohibition of Anti-personnel Mines is without a doubt an excellent starting point and, in general terms, this positive tendency is continuing. In recent years, large stockpiles of mines have been destroyed, funding for mine-destruction programmes has increased with the result that more areas of land have been cleared, thus lowering the number of new victims.

However, there are still many steps to be taken. The way in which advances are made in the coming years will be crucial for the credibility and effectivity of the Convention. It is vital that everyone, governments, international organisations and NGOs, continues our struggle against this weapon of terror that we have been denouncing for years, a weapon still used today by governments and rebel groups in countries around the world, with no punishment.

Prólogo GERVASIO SÁNCHEZ

Cuando en septiembre de 1995 viajé a Kuito (Angola) para hacer mi primer reportaje, no pensé que mi vida iba a quedar minada para siempre por las víctimas de los terribles efectos de las minas antipersona, esos guerreros ocultos o ciegos que no distinguen entre «la pisada de un soldado y la de una anciana o un niño que está recogiendo leña», como dice un informe de Amnistía Internacional.

En noviembre de 1997 publiqué con el apoyo de Intermón, Médicos Sin Fronteras y Manos Unidas un libro titulado *Vidas Minadas* que recogía una visión general sobre este drama y la historia de siete mutilados, una por cada país que visité en cuatro continentes. Durante más de dos años, tres exposiciones fotográficas visitaron la mayoría de las ciudades españolas.

Durante este año he regresado de nuevo a varios de esos países para fotografiar la evolución de las vidas cotidianas de los protagonistas más jóvenes de aquel libro. ¿Quién no siente compasión por las víctimas y la obligación de cuidar de ellas como si fueran sus hijos?

Coincidiendo con el quinto aniversario de la firma del Tratado de Ottawa contra las minas antipersona que se cumple el 3 de diciembre de 2002, quiero presentar esta especie de hijo menor de aquel adulto llamado *Vidas Minadas*. Aquellos niños son hoy jóvenes a punto de empezar o finalizar los estudios secundarios. Todos tienen como principal sueño llegar a la universidad.

El camboyano Sokheum Man ha pasado de ser un niño campesino pobre con dos piernas que difícilmente hubiese terminado la escuela secundaria a convertirse en un activista de la campaña contra las minas con gran proyección internacional que se fotografía con el ex beatle Paul McCartney y da charlas a estudiantes australianos o alemanes. El bosnio Adis Smajic ha necesitado varias operaciones de cirugía estética para reconstruir su cara. La mozambiqueña Sofía Elface Fumo sigue teniendo la misma cara de niña que hace cinco años aunque es madre desde hace tres. La afgana Wahida Abed ha sobrevivido a la intransigencia del régimen talibán aunque su carácter se ha empañado de una profunda tristeza.

Creo con pasión en mi trabajo y considero que la obligación de un periodista es documentar los horribles hechos que se producen a lo largo y ancho de este mundo injusto, pero muchas veces tengo serias dudas sobre si ese trabajo sirve para algo. Aunque, como escribió el portugués Fernando Pessoa, «prefiero la angustia a una paz que me pudra».

«La fotografía podría ser esa tenue luz que modestamente nos ayudara a cambiar las cosas», dijo W. Eugene Smith después de documentar entre 1971 y 1975 el envenenamiento con mercurio de los habitantes de la población pesquera de Minamata (Japón), muchos de los cuales sufrieron terribles enfermedades nerviosas. Igual que él, sueño con que algún día los responsables de los gobiernos más poderosos del mundo se dejen influir por «esa tenue luz» y comiencen a tomar las decisiones necesarias para evitar el sufrimiento de los civiles, las principales víctimas y la única verdad de los conflictos armados modernos.

Preface GERVASIO SÁNCHEZ

When I went on my first assignment to Kuito (Angola) in September 1995, I did not realise that my life would be blown away forever by the victims of the terrible effects of antipersonnel mines, those hidden, blind warriors that do not distinguish between «the footfall of a soldier and that of an old woman or a child looking for firewood», as a report from Amnesty International puts it.

In November 1997, with the support of Intermón, Médicos sin Fronteras and Manos Unidas, I published a book called Vidas Minadas *(Mined Lives), containing a panorama of this drama and the story of seven wounded people, one for each of the countries I visited in four continents. For over two years, three photo exhibitions travelled round most of the cities of Spain.*

Over this past year, I returned again to some of those countries, to photograph the development of daily life for the youngest of the people portrayed in my book. Who does not feel compassion for the victims and the obligation to care for them as if they were one's own children?

Coinciding with the fifth anniversary of the signing of the Ottawa Treaty against antipersonnel mines, on 3rd December 2002, I want to present this kind of younger son of that adult called Vidas Minadas. *The children of that book are now young people about to start or finish high school. The greatest dream for them all is to be able to go to university.*

Sokheum Man, from Cambodia, has gone from being a poor peasant child with two legs and very little chance of finishing secondary school to becoming an anti-landmine campaigner with great international coverage, photographed with ex-Beatle Paul McCartney and giving talks to Australian or German students. Adis Smajic, Bosnian, has had to undergo several operations to reconstruct his face. Sofia Elface Fumo, from Mozambique, still looks much like the little girl she was five years ago, although her own child is now three years old. Wahida Abed, from Afghanistan, has survived the Taliban hardships, although her personality has become imbued with a deep sadness.

I believe passionately in my work and I think that reporters have the obligation to document the terrible events that take place all over our unjust world, but I often have serious doubts as to whether our work is actually of any use. Although, as the Portuguese writer Fernando Pessoa said, «I prefer suffering anguish to a peace that rots me».

«Photography could be that weak light that modestly helps us change things», said W. Eugene Smith after documenting the mercury poisoning of the inhabitants of a fishing village called Minamata (Japan), between 1971 and 1975, where many of the villagers were affected by terrible nerve diseases. Just like him, I dream that one day the people in the most powerful governments of the world will be influenced by that «weak light» and will begin to take the necessary decisions to avoid suffering on the part of civilians, the main victims and the only truth of modern armed conflicts.

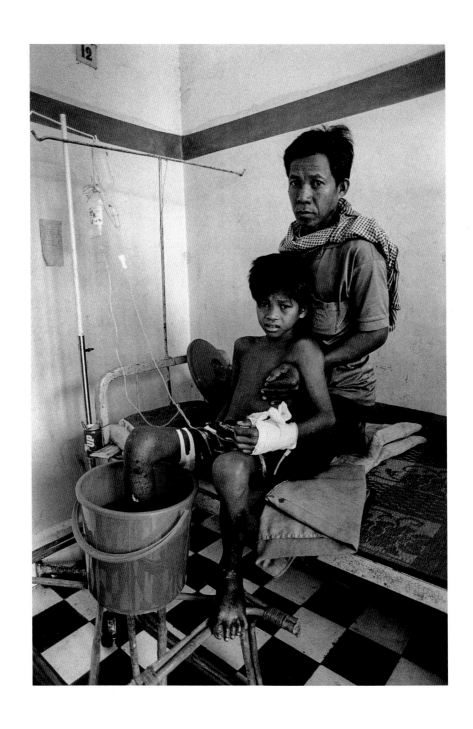

Enero de 1996. Hospital de Siemreap, Camboya
January 1996. Siemreap Hospital, Cambodia

Sokheum Man

Lojong (Camboya) *(Cambodia)*

Trece días después de que una mina le hiriese cuando se dirigía al colegio, Sokheum Man sufrió la amputación de su pierna derecha. Era enero de 1996, tenía 14 años, vivía en Lojong, pequeña aldea situada a 45 kilómetros de los míticos templos de Angkor, y pertenecía a una familia campesina pobre pero muy estructurada.

Más de seis años después de su accidente, Sokheum estudia en la escuela secundaria de Siem Reap y vive en la casa perteneciente a los jesuitas con Man Men, de 15 años, también mutilado por una mina desde los 10.

Según el obispo Enrique (Kike) Figaredo, este joven camboyano tiene madera de líder y un don natural para el arte. «No será un líder carismático, pero se ha forjado una personalidad que puede ayudar mucho a los camboyanos. La mutilación le ha permitido asumir los problemas de su país en su propio cuerpo», afirma el obispo.

Sokheum es un deportista muy competidor. Siempre está dispuesto a jugar con niños discapacitados por enfermedades como la poliomielitis. En sus vacaciones escolares suele acompañar al obispo Figaredo durante sus visitas pastorales (ambos duermen una siesta después de una larga jornada en la fotografía que cierra su reportaje). A sus veinte años se ha convertido en uno de los activistas más importantes de la campaña internacional contra las minas. Viaja varias veces al año al extranjero para participar en encuentros con víctimas de otros países y dar conferencias en escuelas y universidades.

Thirteen days after being wounded by a landmine, on his way to school, Sokheum Man had to have his right leg amputated. This was in January 1996, he was 14 years old, the child of a poor, but well organised peasant family living in Lojong, a small village forty-five kilometres from the legendary temples of Angkor.

More than six years after his accident, Sokheum is studying in Siem Reap secondary school and lives with Man Men, a 15-year-old who was also wounded by a mine when he was 10, in a house belonging to the Jesuits.

According to Bishop Enrique (Kike) Figaredo, this young Cambodian man has the traits of a leader and a natural flair for art. «He will not be a charismatic leader, but he has forged a personality which can greatly help the Cambodians. The amputation has helped him take on the problems of his country in his own body», says the bishop.

Sokheum is a highly-competitive athlete. He is always prepared to play with children handicapped by diseases like polio. During his school holidays he usually accompanies the bishop on his pastoral visits (they are both having a siesta after a long day's work in the last picture of this photo-essay).

At twenty, he has become one of the most important campaigners in the international effort against landmines. He travels abroad several times a year to take part in meetings with victims from other countries and to give conferences in schools and universities.

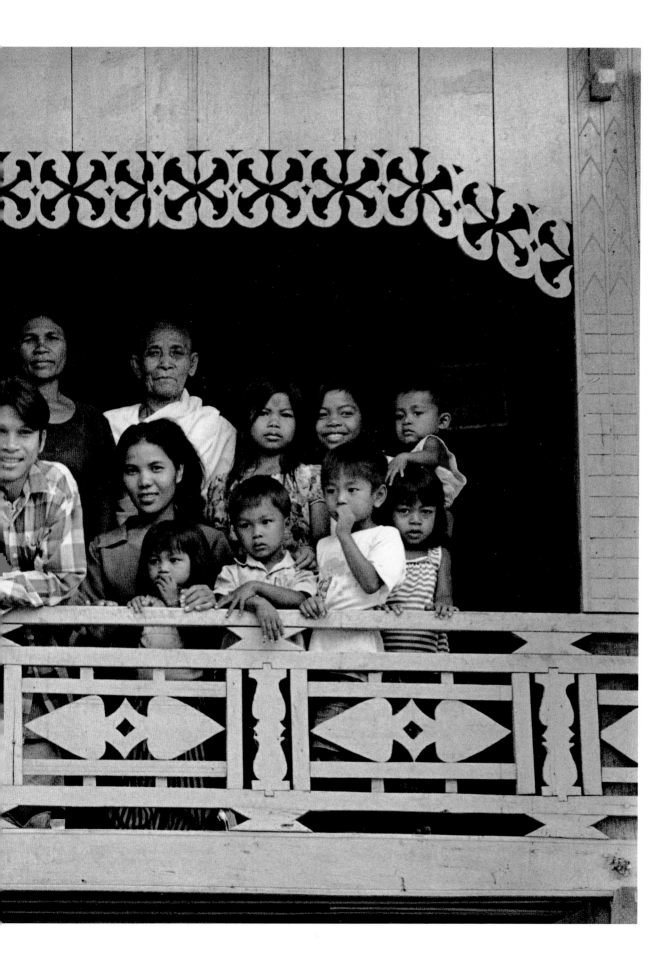

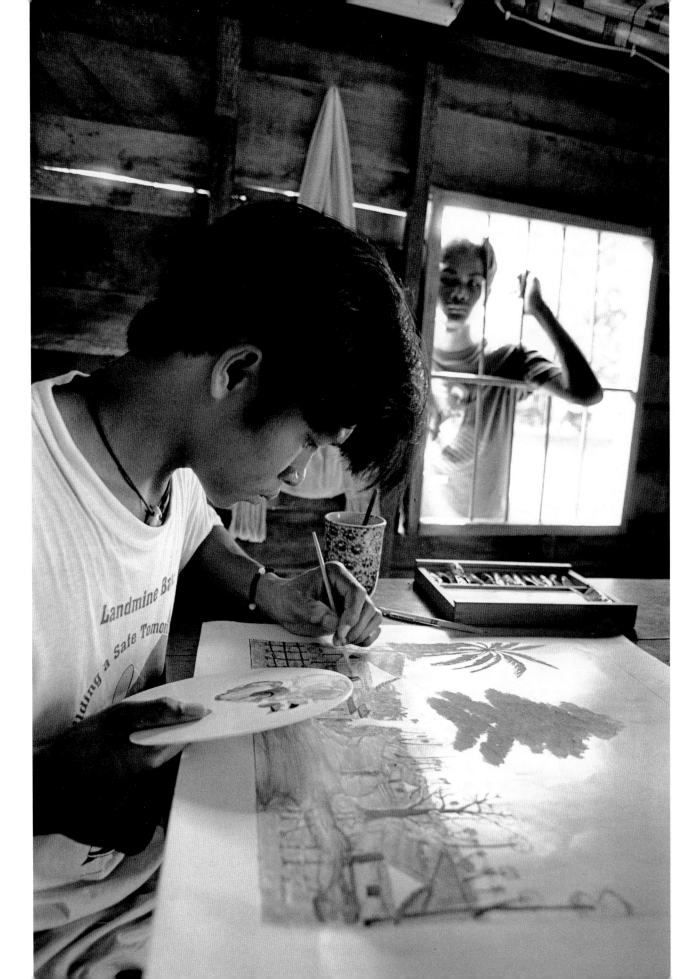

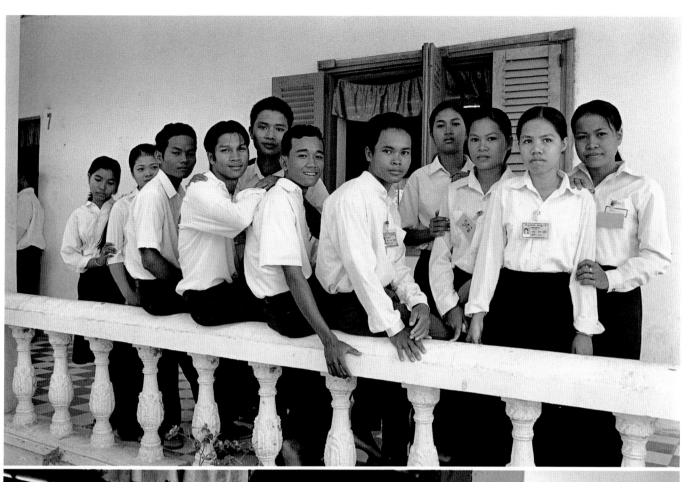
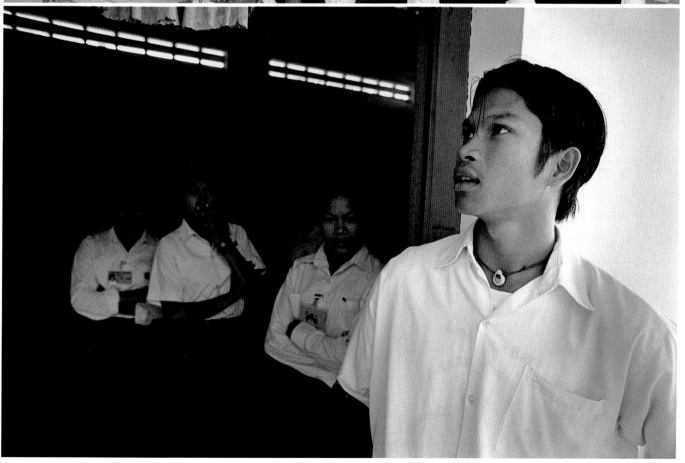

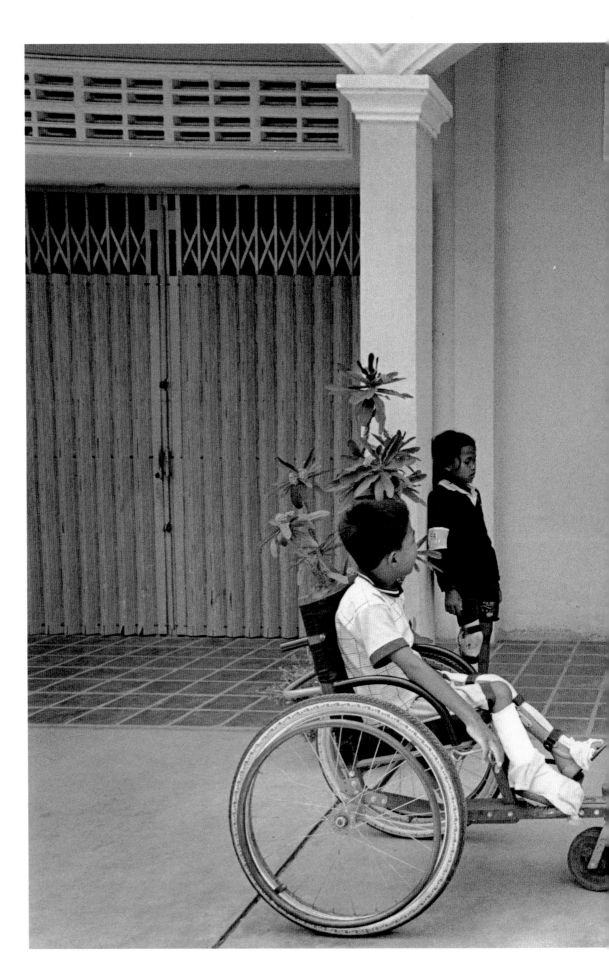

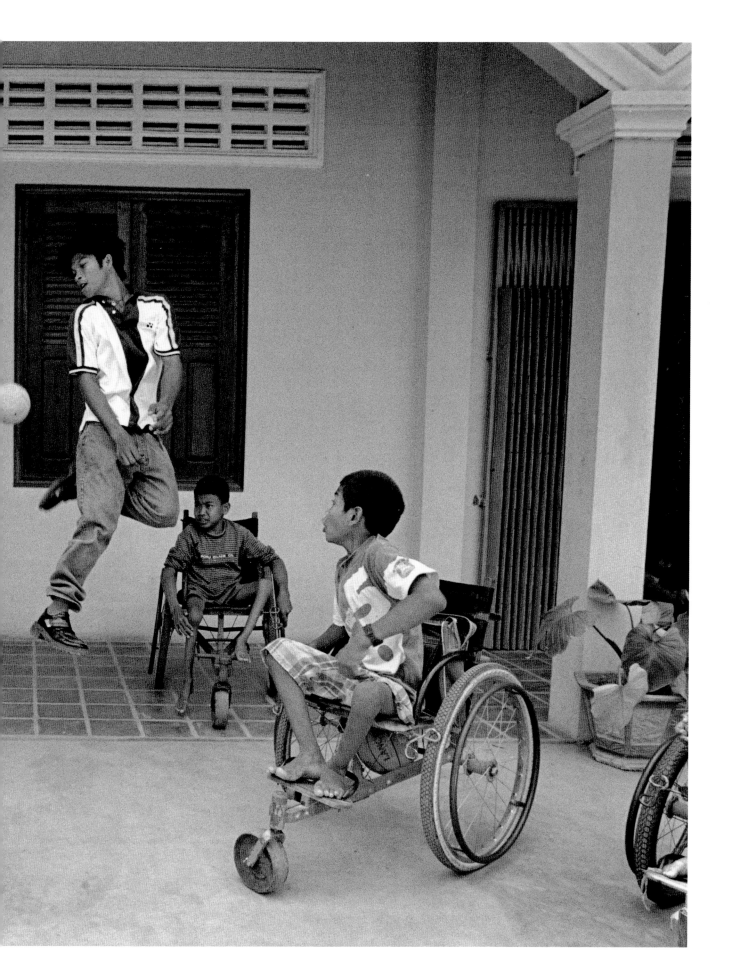

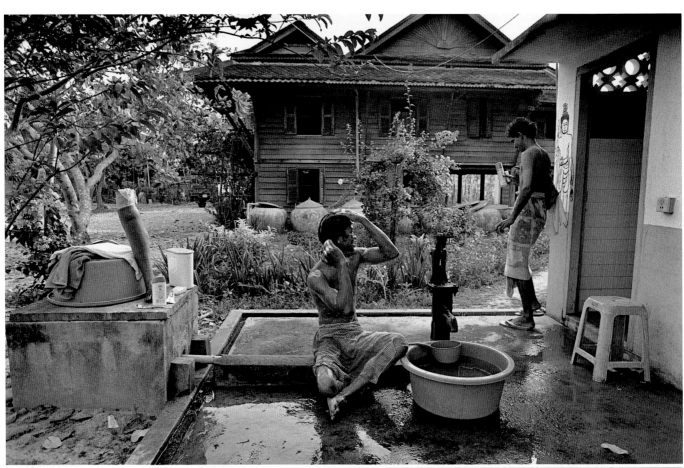

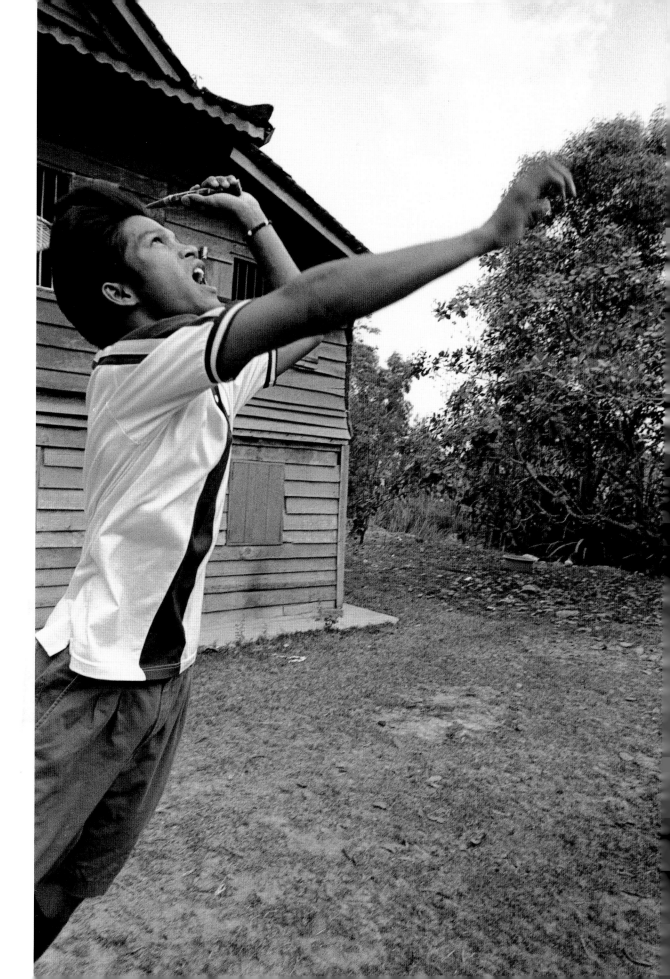

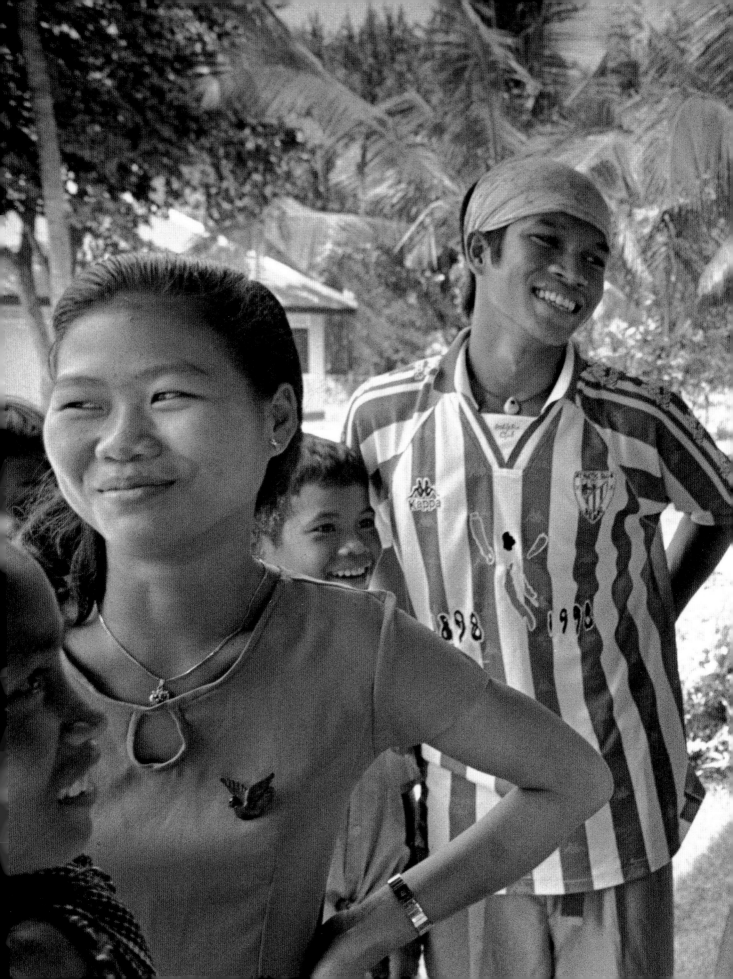

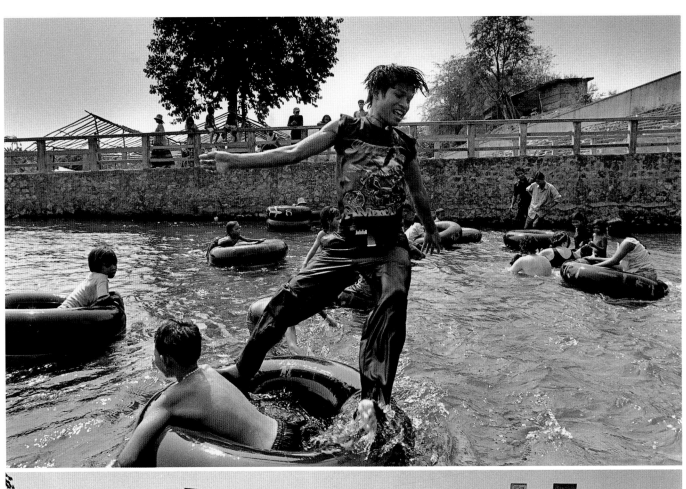

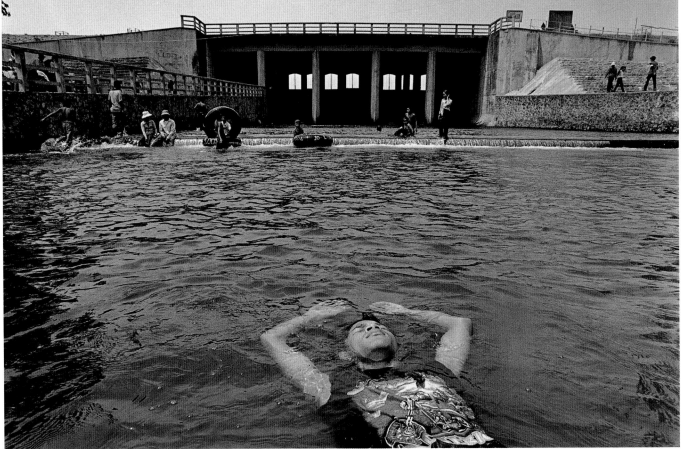

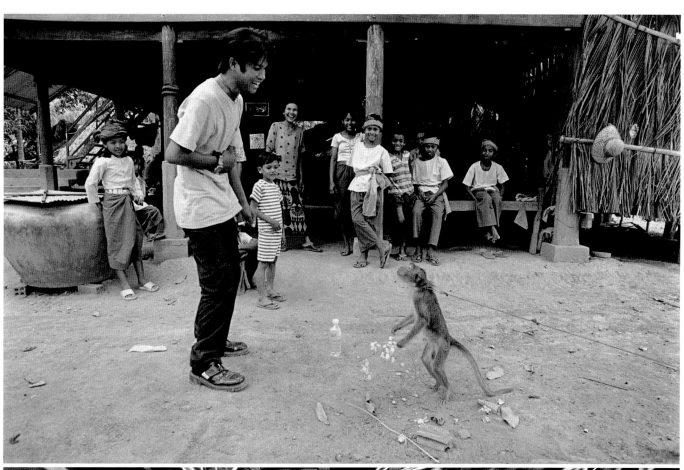

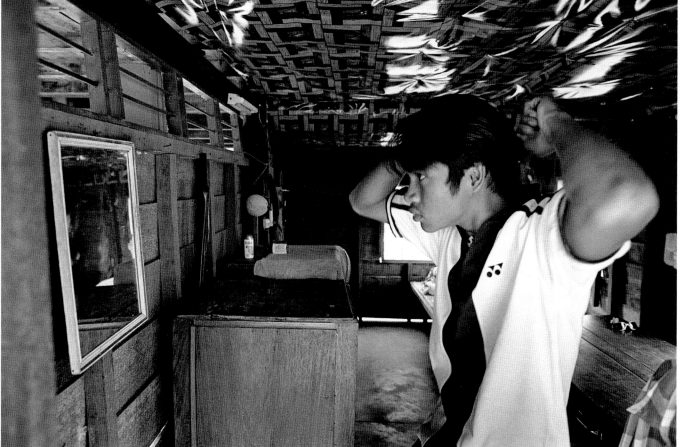

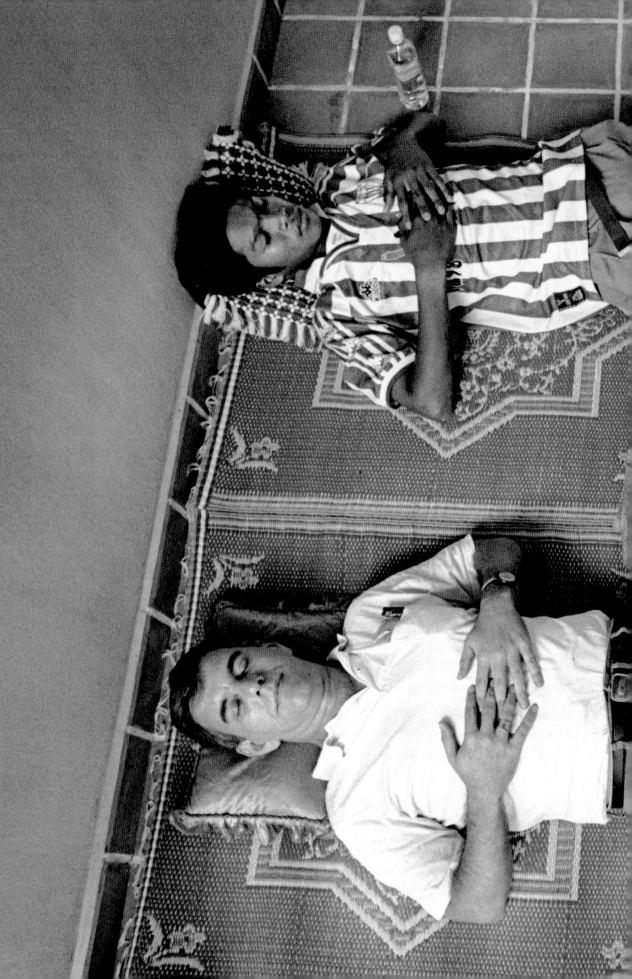

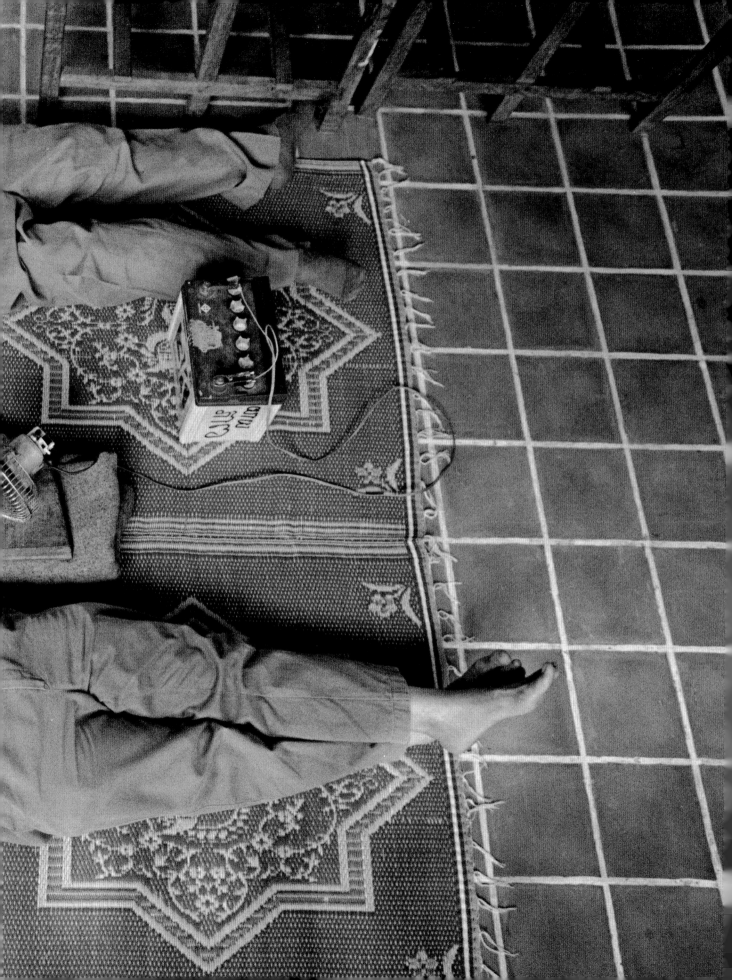

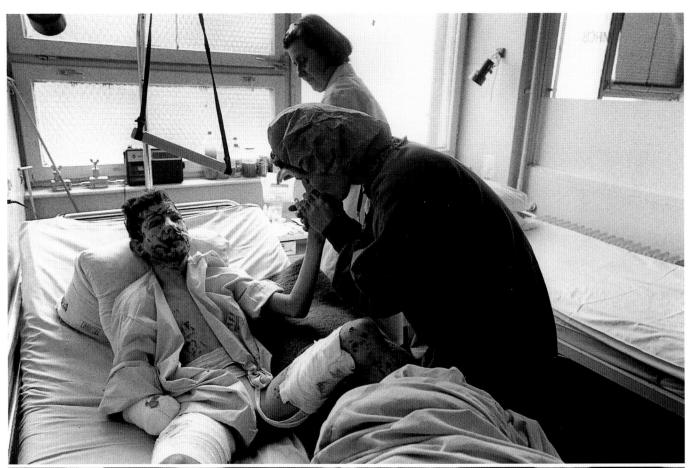
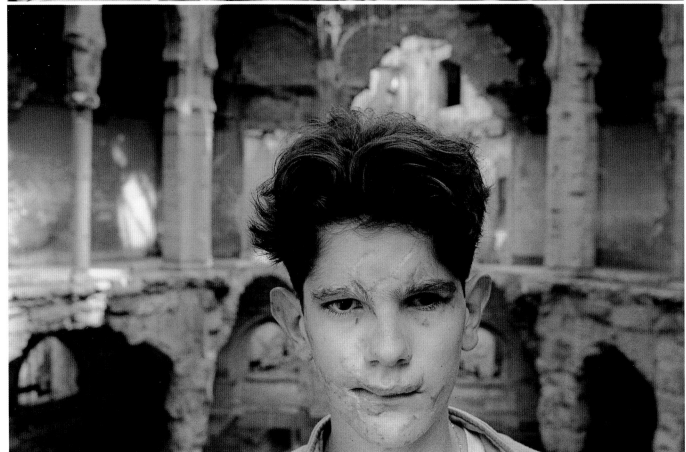

Adis Smajic

Sarajevo (Bosnia-Herzegovina)

Era marzo de 1996, tenía 13 años, había sobrevivido a cuatro años de cerco salvaje y caminaba con unos amigos por la principal línea de confrontación cuando vio la mina semidescubierta. Al levantarla del suelo le explotó cerca de la cara, provocándole la pérdida de su ojo izquierdo, su mano derecha y profundas cicatrices que le desfiguraron la cara.

Adis ya había sufrido la pérdida de su padre durante un bombardeo con morteros al inicio de la guerra. Su abuela fue herida por un francotirador y su casa alcanzada por disparos de cañones.

La embajada italiana lo trasladó a un hospital cercano a Venecia donde pasó seis meses. En septiembre de 1997, la entonces presidenta de la compañía de seguros DKV-Previasa, Pilar Muro, se interesó por su caso y decidió asumir el coste de varias operaciones de cirugía estética. La compañía encargó esta difícil tarea al prestigioso cirujano plástico Antonio

In March 1996, Adis Smajic was 13, and had survived four years of savage siege in the city; he and some friends were walking along the main borderline of the conflict when he saw a half-buried landmine. When he picked it up it exploded near his face, and he lost his left eye and his right hand, as well as suffering deep scarring which disfigured his face.

Adis had already lost his father during a mortar bombardment at the beginning of the war. His grandmother was wounded by a sniper and his house had been affected by cannonfire.

The Italian Embassy moved him to a hospital near Venice, where he spent six months. In September 1997, the then-president of the DKV-Previasa insurance company, Pilar Muro, heard about his case and decided to underwrite the cost of several plastic surgery operations. The company asked the prestigious plastic surgeon Antonio Tapia, part of the medical board of Clinica Quirón in Barcelona, to undertake the task.

Marzo de 1996. Hospital de Kosevo
March 1996. Kosevo Hospital

Tapia, miembro del cuadro médico de la Clínica Quirón de Barcelona.

Adis visitó por primera vez la ciudad en diciembre de 1997, coincidiendo con la firma del Tratado de Ottawa para la prohibición de las minas antipersona. Después de un chequeo completo para conocer su estado de salud, el doctor Tapia decidió que Adis sería sometido a tres operaciones para eliminar sus cicatrices y reconstruirle el rostro. La última operación (a la que pertenecen algunas imágenes de este libro) fue realizada en julio de 2002. Adis siempre ha viajado a Barcelona acompañado de su hermana Mirela. Desde su accidente ha sufrido más de una veintena de operaciones, seis de ellas de cirugía estética.

Hoy Adis es un joven de veinte años, que mide 1,95 cm, a quien le encanta el *hip hop* y el fútbol, deporte que práctica con bastante solvencia a pesar de sus limitaciones físicas. Sigue viviendo en Sarajevo con su madre Zineta y su hermana en el barrio de Dobrinja, uno de los más afectados por la guerra, y visita a menudo a Elmaza, su abuela materna. Su abuelo materno murió de un ataque al corazón menos de un mes después de su accidente con la mina. Está a punto de finalizar sus estudios secundarios. Su sueño es convertirse en un ingeniero de sonido (le gusta hacer mezclas con su ordenador) y vivir en Nueva York.

Adis came to Barcelona for the first time in December 1997, coinciding with the signature of the Ottawa Treaty to ban anti-personnel landmines. After a complete check-up on his state of health, Dr Tapia decided that Adis would have to undergo three operations to remove the scars and reconstruct his face. The last operation (of which there are some photos in this book) took place in July 2002. Adis always travels to Barcelona with his sister Mirela. Since his accident he has had over twenty operations, six of them plastic surgery.

Today, Adis is a six-foot-five (1.95 m) twenty-year old, who adores hip-hop and football, which he plays very well despite his physical limitations. He still lives in Sarajevo with his mother Zineta and his sister, in the Dobrinja neighbourhood, one of the areas worst affected by the war, and he often visits Elmaza, his maternal grandmother. His maternal grandfather died of a heart attack less than a month after Adis' accident with the mine. He is about to finish his high school studies and his dream is to become a sound engineer (he loves creating mixes with his computer) and live in New York.

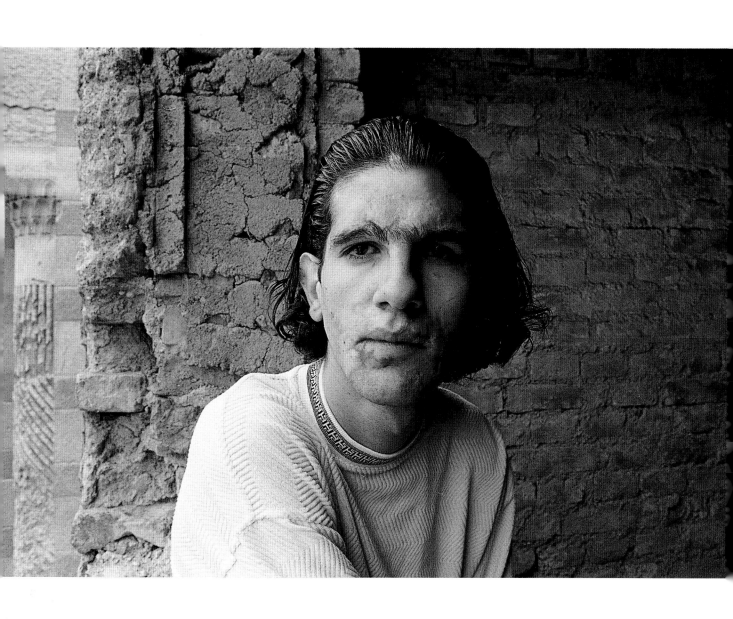

Julio de 2002. Biblioteca de Sarajevo
July 2002. Sarajevo Library

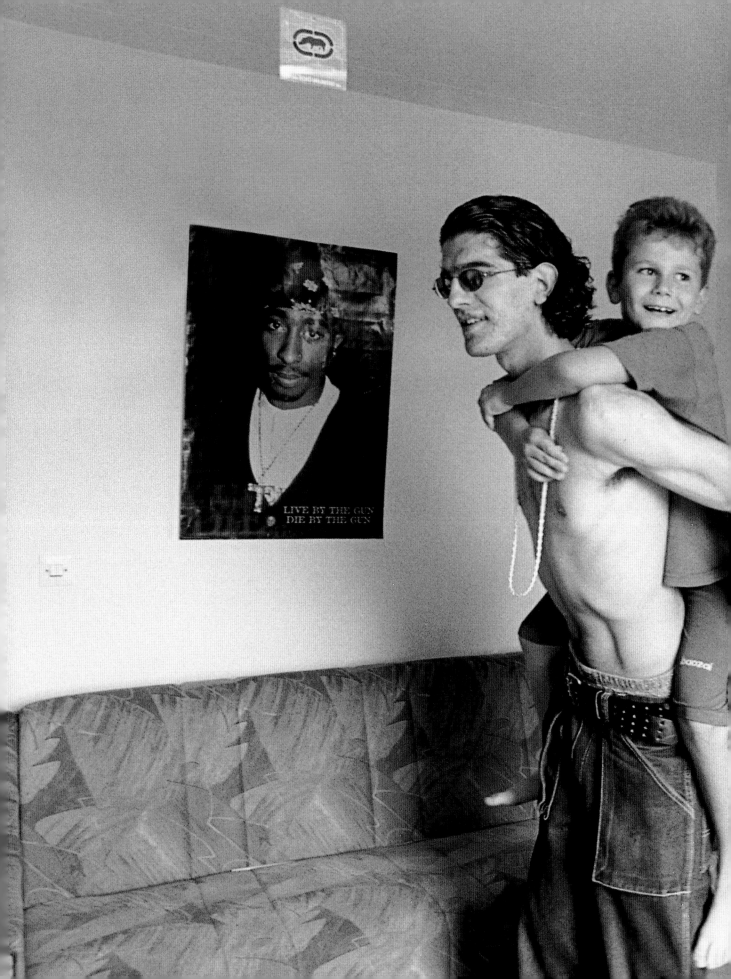

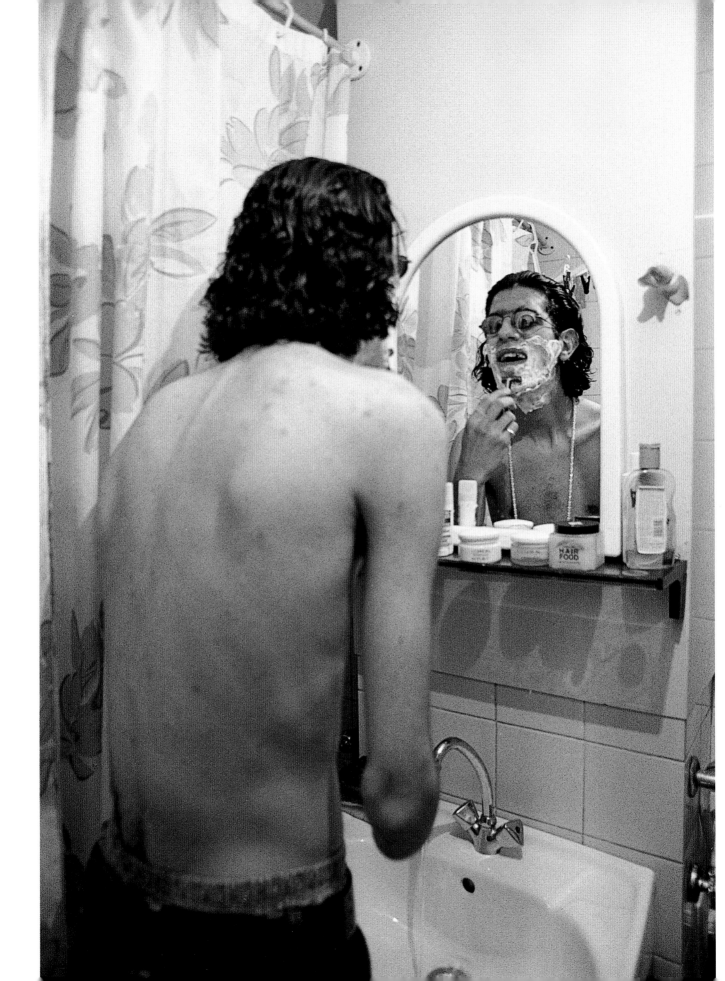

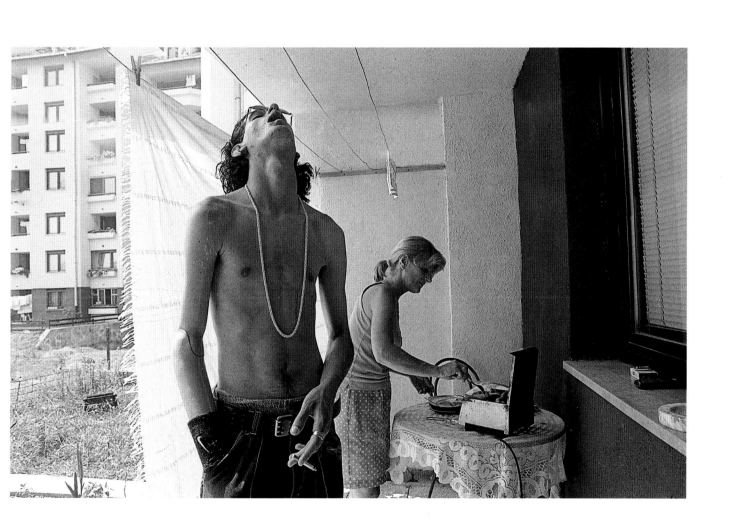

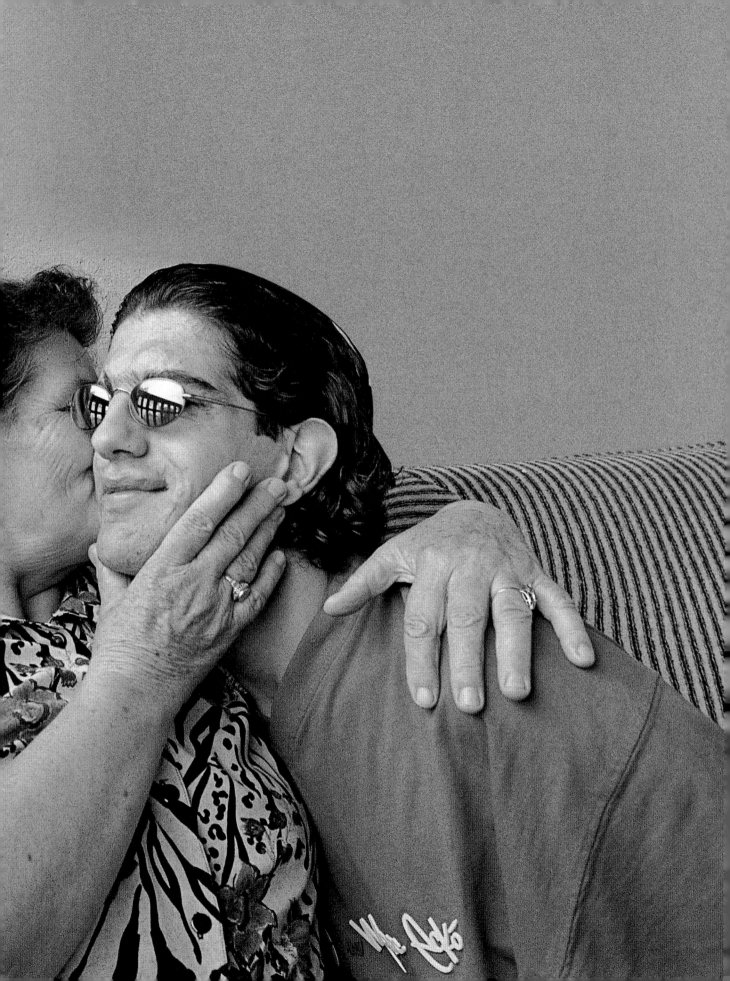

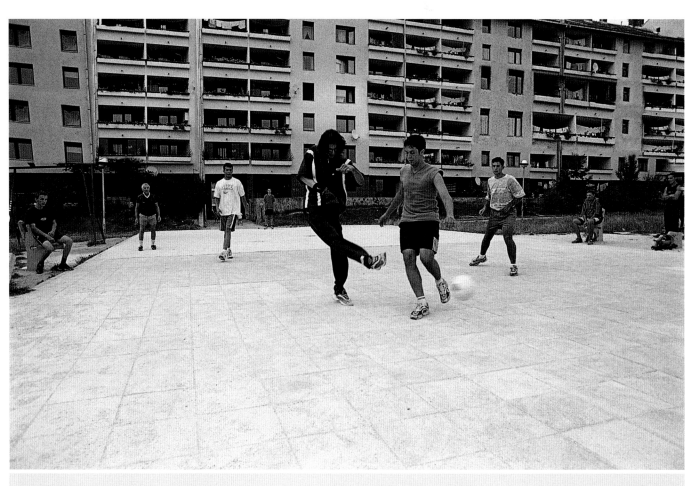

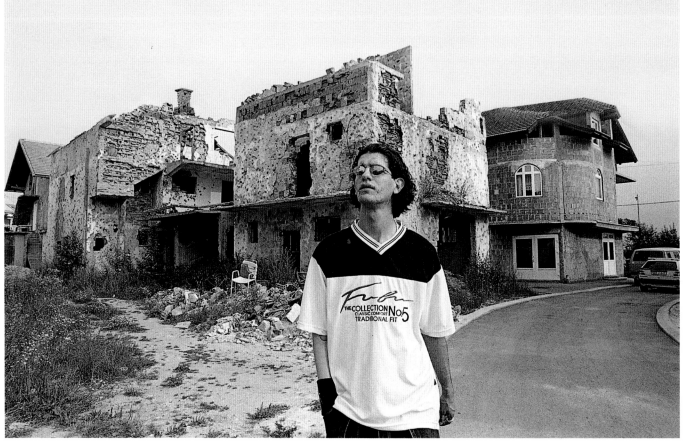

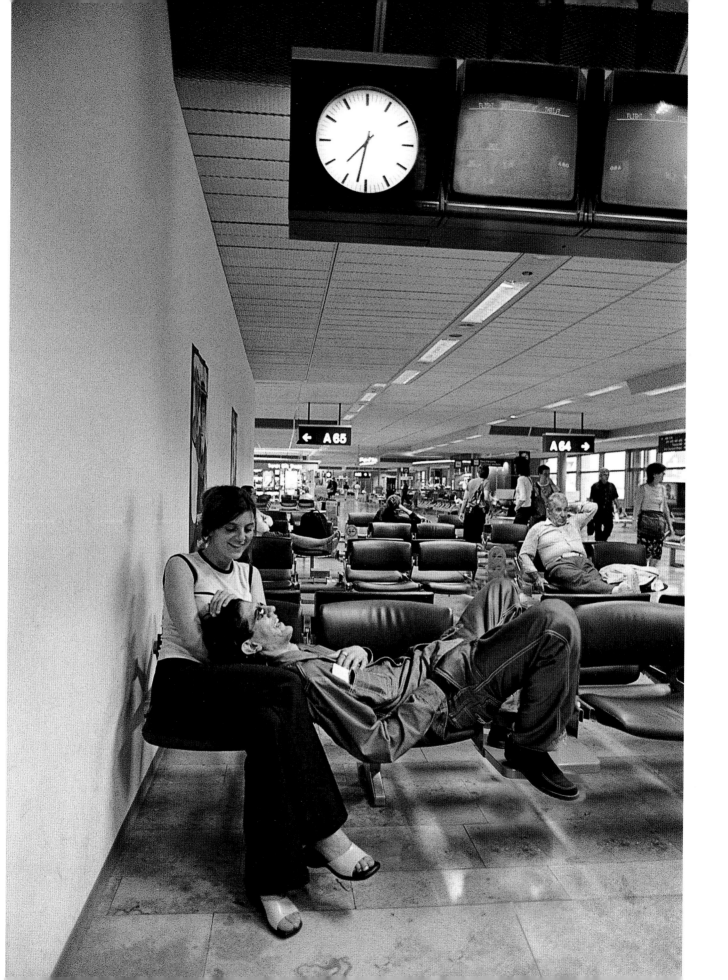

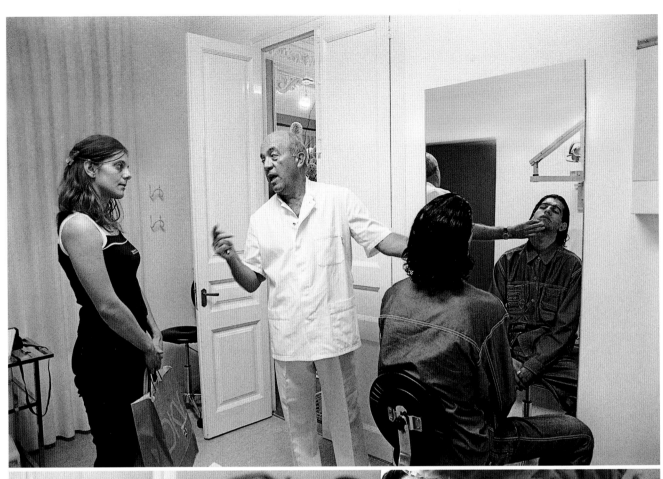

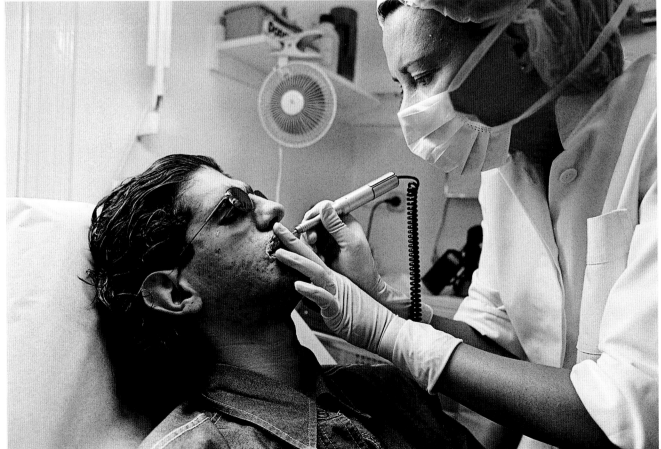

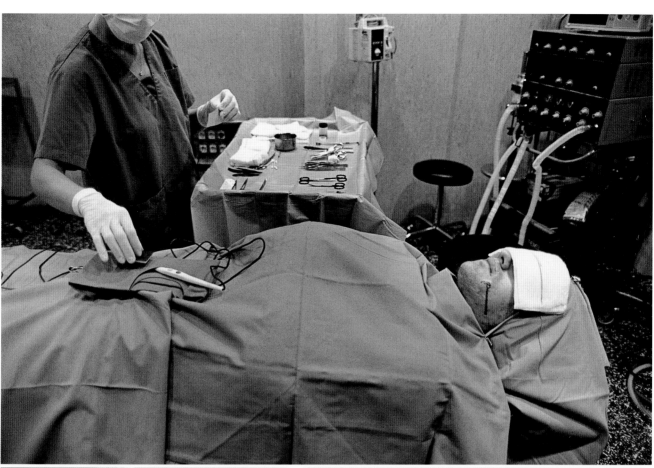

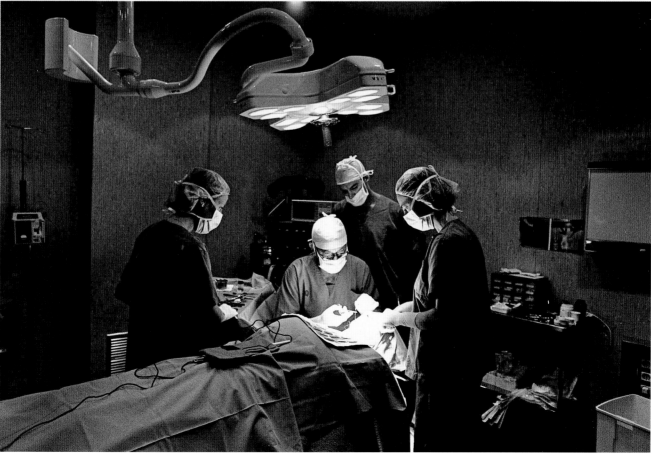

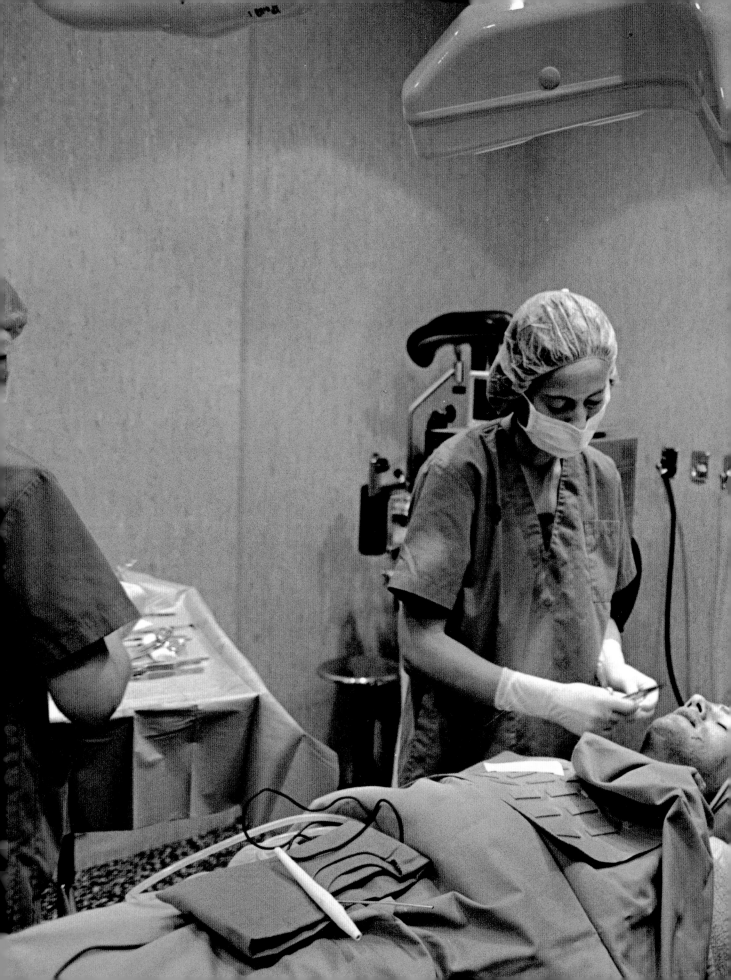

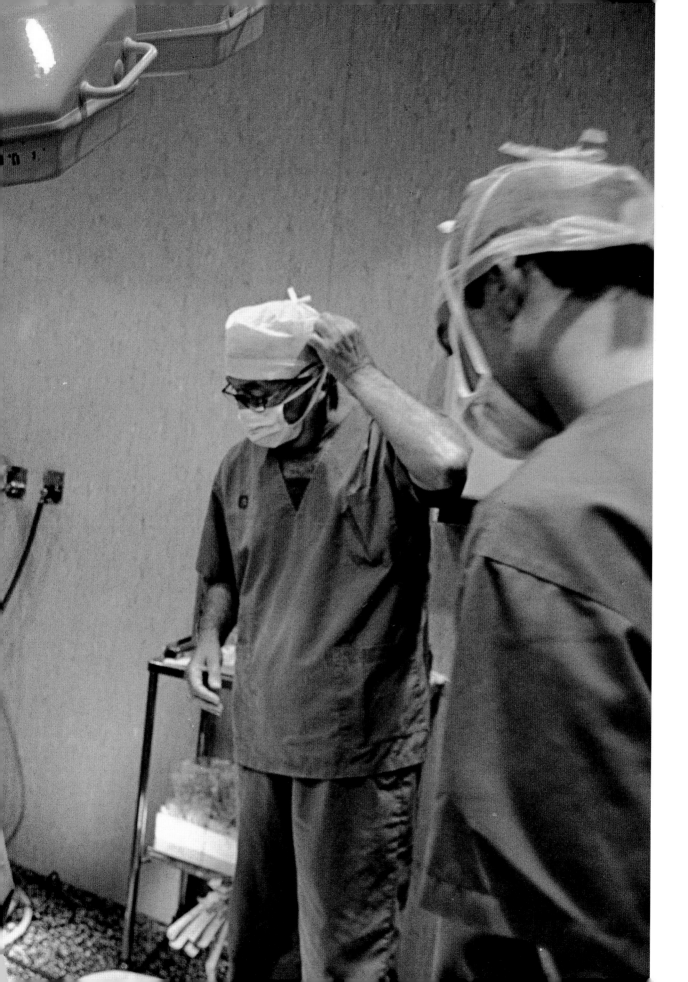

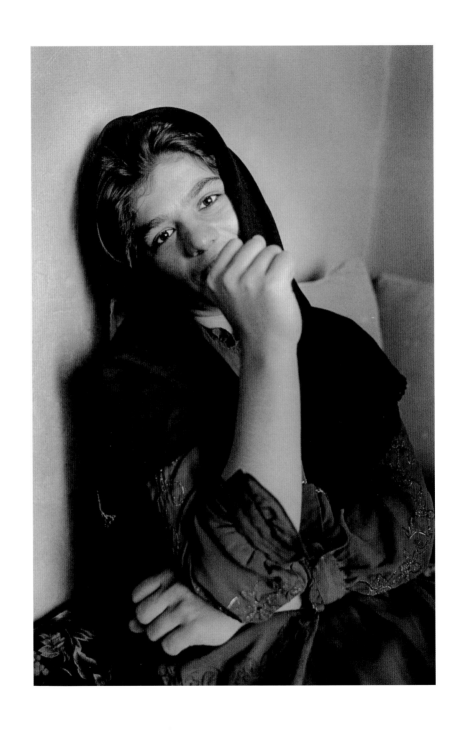

Agosto de 1996. Kabul
August 1996. Kabul

Wahida Abed

Kabul (Afganistán) *(Afghanistan)*

La explosión de una mina situada en el cercado que rodeaba su casa arrancó ambas piernas a Wahida Abed cuando tenía once años. Los señores de la guerra, hoy encumbrados a los puestos dirigentes del Afganistán postalibán, combatían por cada palmo de terreno afgano y la población civil pagaba el precio de los desmanes. Tanto su padre como sus hermanos desaparecieron o murieron durante la larga guerra civil iniciada a finales de los años ochenta, después de la retirada soviética. Hasta septiembre de 1996 Wahida consiguió sobrevivir gracias al salario que percibía por participar en un proyecto educativo de sensibilización sobre el peligro de las minas en las escuelas de Kabul.

La ocupación de la capital por los talibanes provocó su expulsión del trabajo y la reclusión en su casa, donde vivía con su madre y su hermana. Los talibanes cerraron las escuelas femeninas y obligaron a las mujeres a vivir como sombras furtivas que sólo podían salir a la calle acompañadas de un familiar adulto. Wahida enseñó a varios niños y adolescentes a trabajar en el telar que tiene en su casa y sobrevivió con la venta de tapices.

La intransigencia talibán ha golpeado duramente a Wahida, que ha pasado de ser una adolescente segura de sí misma y risueña a una mujer que mira con desconfianza y oculta su rostro en público. Desde que hace doce años perdió sus dos piernas, ha tenido que cambiar ocho veces de prótesis en el centro ortopédico de la Cruz Roja Internacional, dirigido por el italiano Alberto Cairo.

The explosion of a landmine located in the fence around her house tore off both Wahida Abed's legs when she was eleven. The war lords, now elevated to the highest ranks of the post-Taliban Afghan government, were then fighting over each inch of Afghan territory and the civilian population paid the price of their ruthlessness. Her father and brothers all disappeared or were killed during the long civil war, which started at the end of the nineteen-eighties, after the Soviet Union's retreat. Until September 1996, Wahida had managed to survive thanks to the wages she earned for her participation in an educational project to raise awareness about the danger of landmines in schools in Kabul.

When the Taliban occupied the capital, she was dismissed from work and had to stay inside her home, where she lived with her mother and her sister. The Taliban closed all girls' schools and forced women to live like furtive shadows, only allowed out in the streets if they were accompanied by an adult male relative. Wahida taught several children and teenagers to work on the loom she had at home and she survived by selling tapestries.

The rigid Taliban regime has hit Wahida hard, and she has changed from a self-assured, laughing teenager into a woman whose eyes show mistrust and who hides her face in public. Since she lost her legs twelve years ago, she has had to have the artificial limbs changed eight times, in the International Red Cross orthopedic centre, run by Alberto Cairo, an Italian.

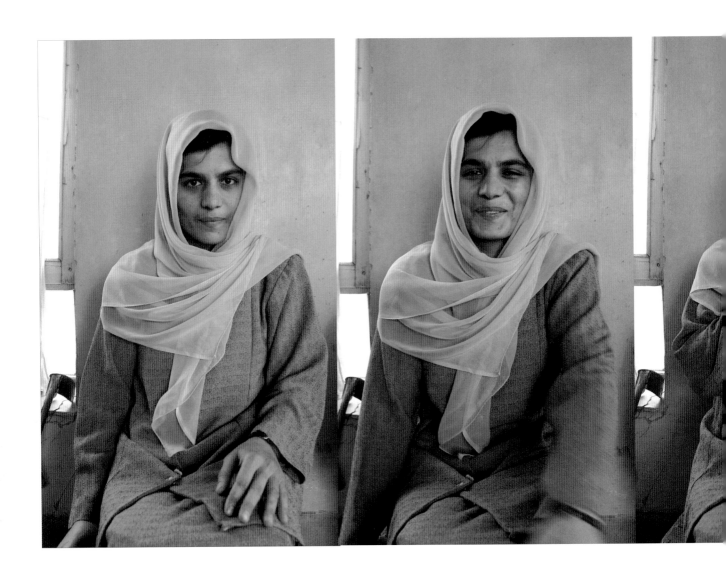

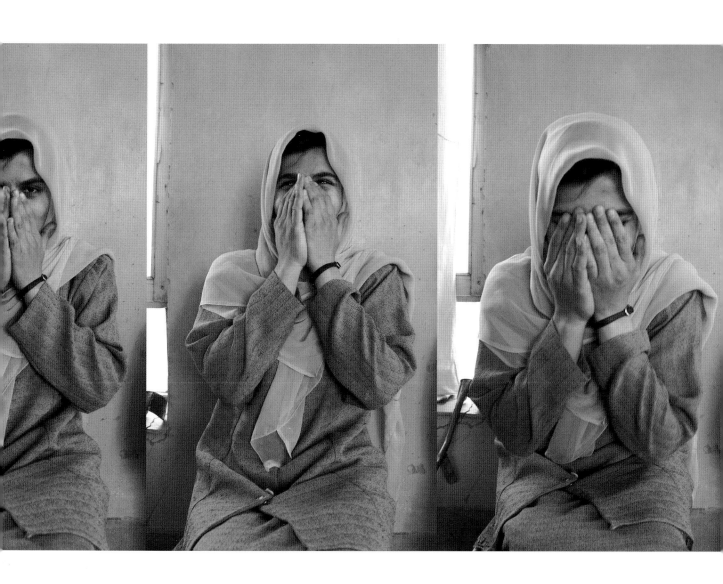

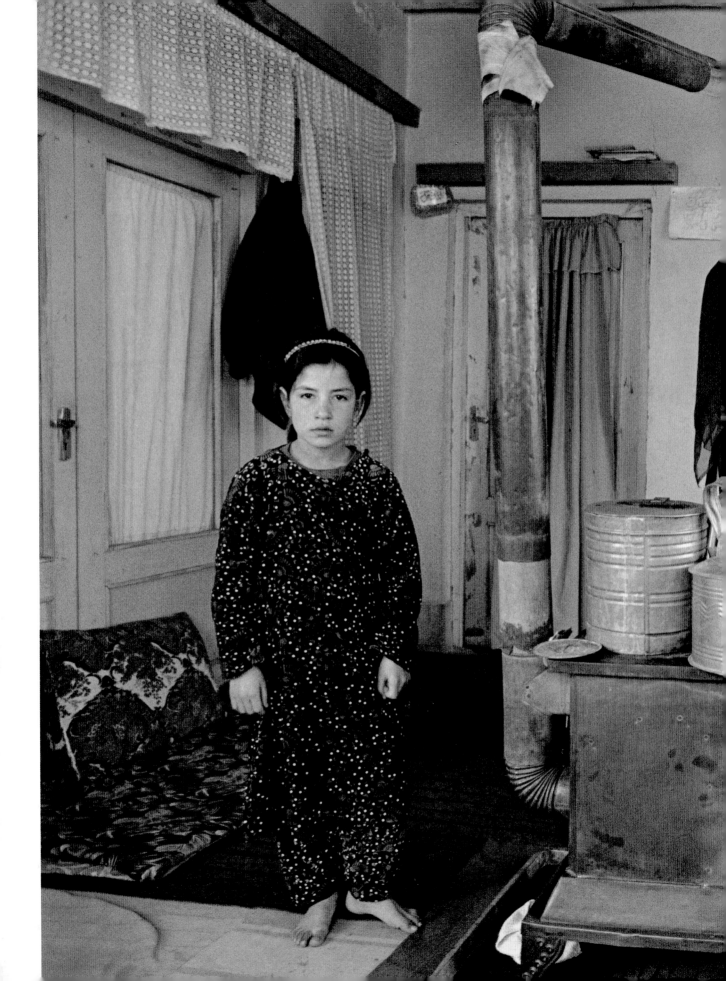

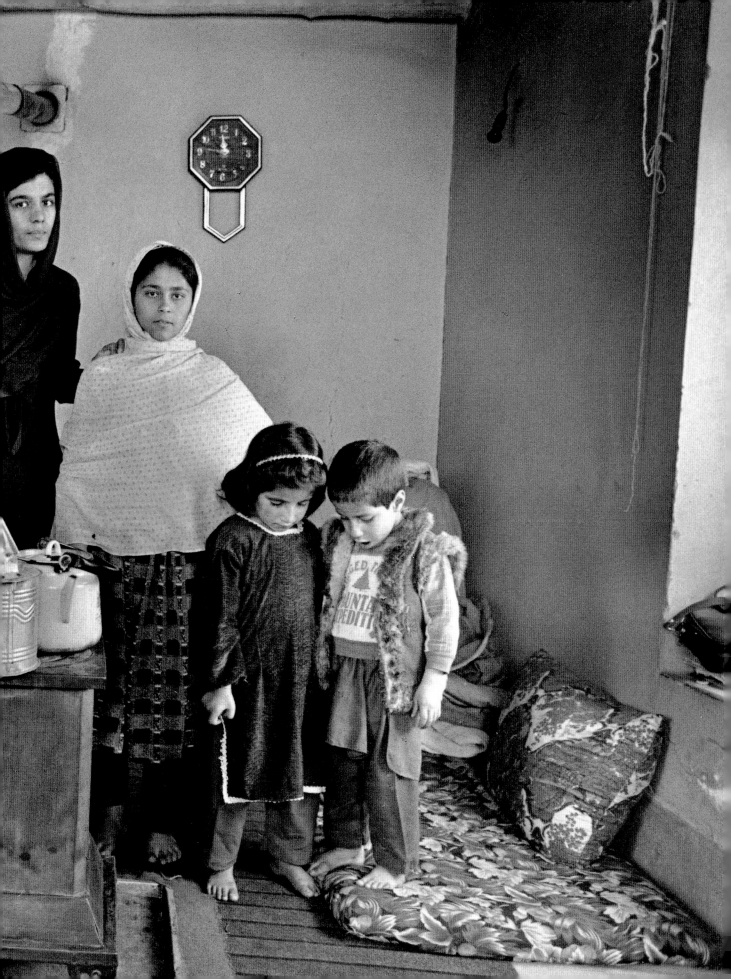

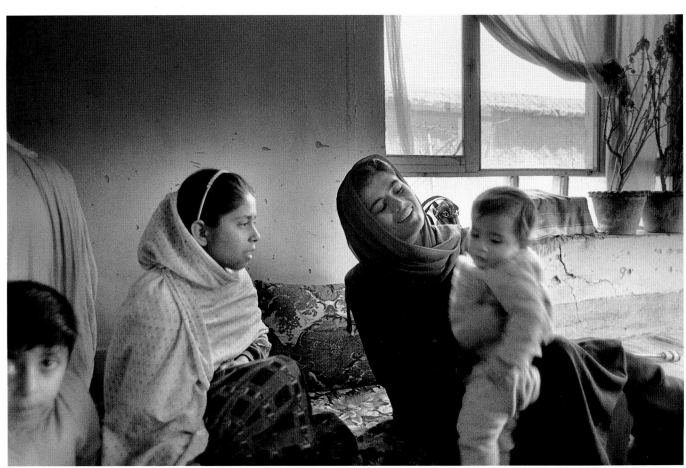

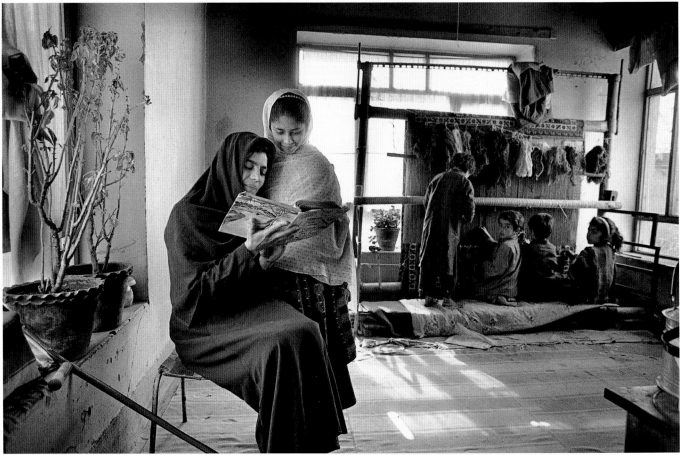

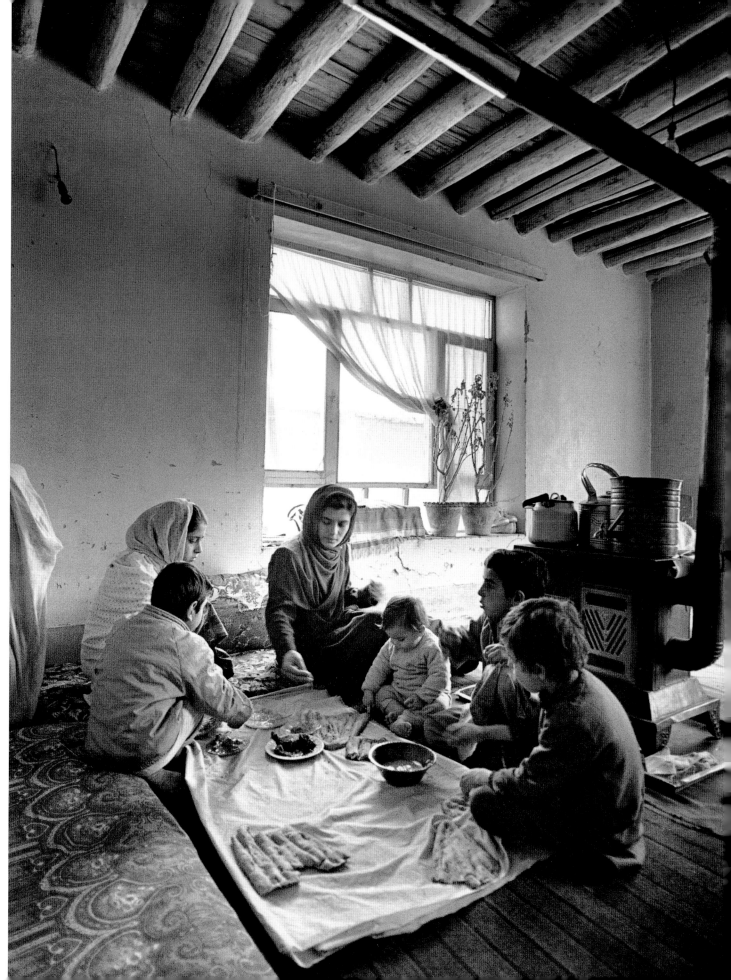

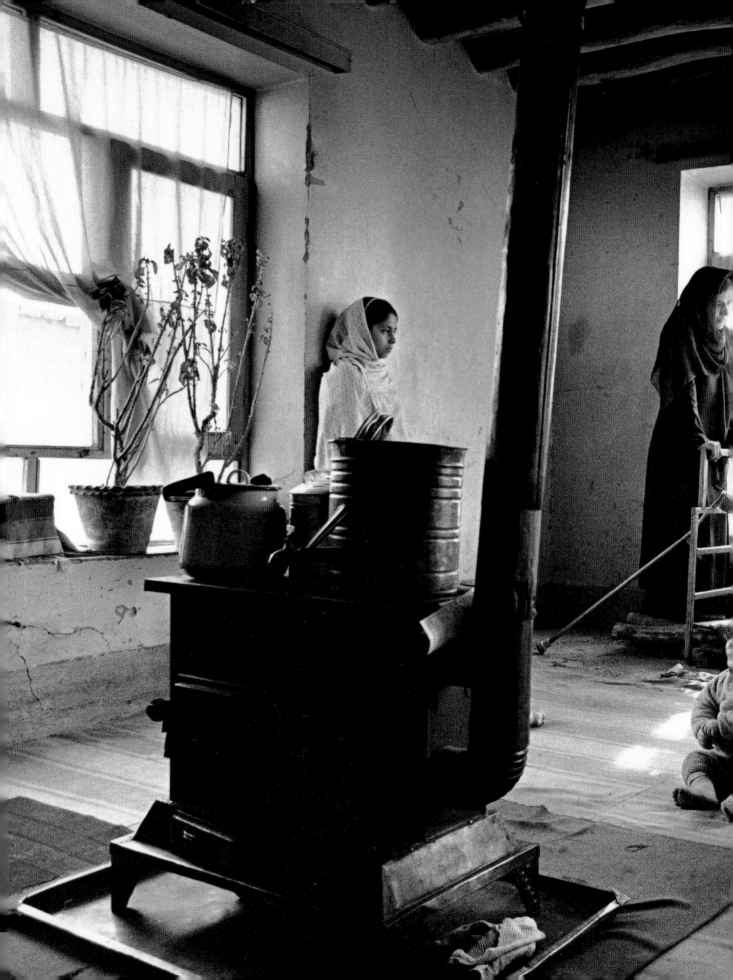

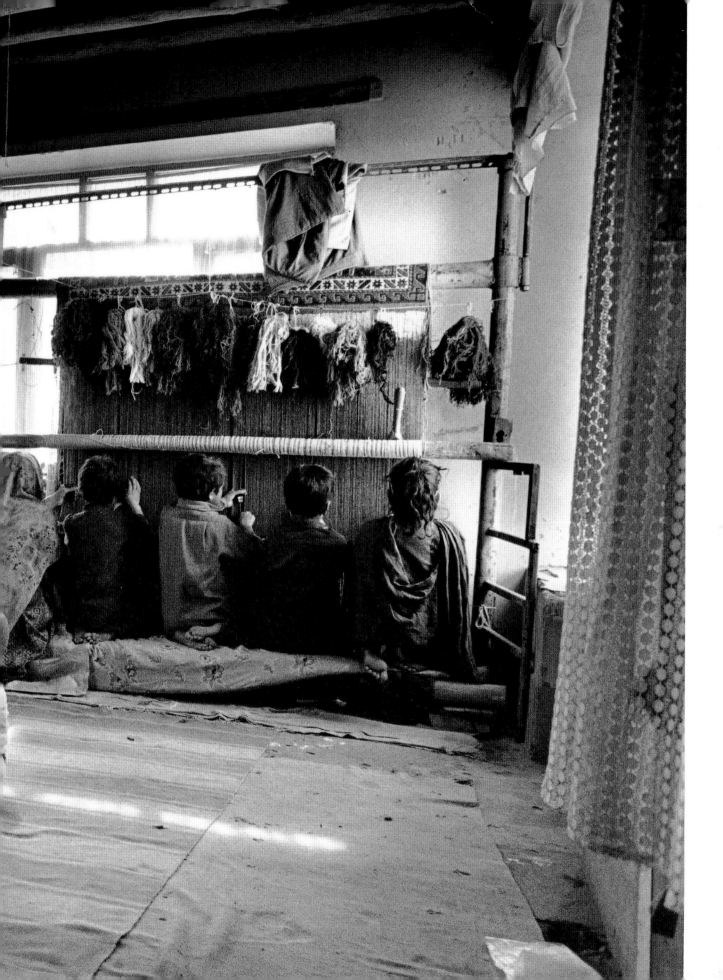

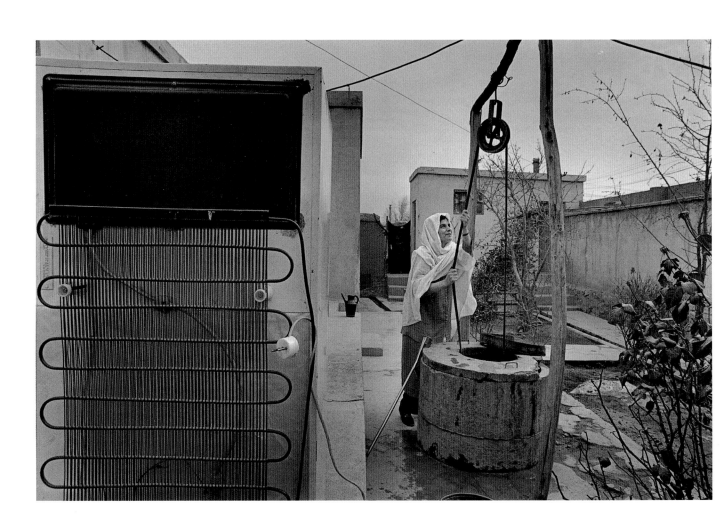

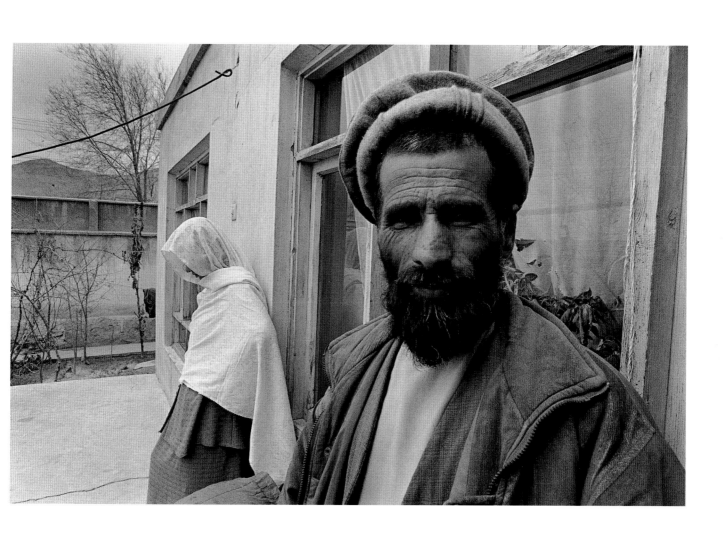

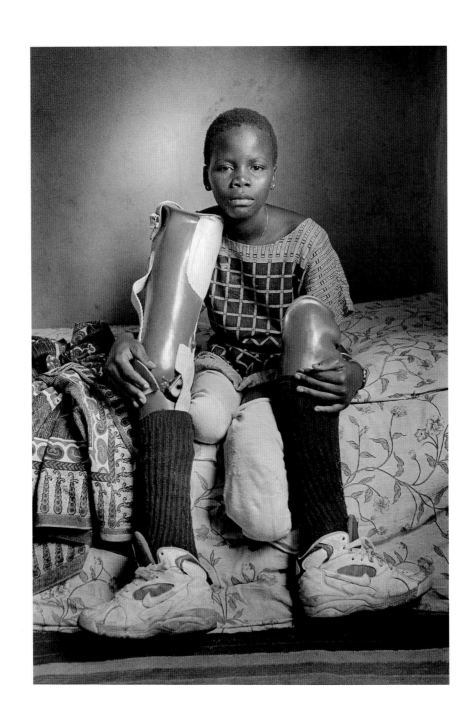

Febrero de 1997. Boane
February 1997. Boane

Sofía Elface Fumo

Boane (Mozambique)

Una mina amputó a Sofía Elface Fumo sus dos piernas mientras recogía leña cerca de su casa. Era febrero de 1993 y tenía diez años. En la explosión también murió su hermana María, de ocho años. Su padre había fallecido tres años antes. Otro golpe muy duro fue la muerte por enfermedad de su hermana Anita, con la que mantenía una relación muy especial. Ocurrió el 4 de marzo de 1998, día del cumpleaños de Sofía. Desde julio de 1999 es madre de un niño llamado Leonaldo al que educa sin la ayuda del padre, que la abandonó después de dejarla embarazada.

Sofía tiene que andar cada día una hora para asistir al último curso del segundo ciclo de primaria en la escuela comunal, situada a 2 kilómetros de su casa. El año que viene irá a la escuela secundaria, que se encuentra a 9,5 kilómetros de donde vive. Utilizará una silla de ruedas con un manillar especial donado por dos organizaciones humanitarias españolas.

In February 1993, when she was ten, a mine blew off both of Sofia Elface Fumo's legs when she was collecting firewood near her house. Her eight-year-old sister Maria died in the explosion. Sofia's father had died three years earlier. Another hard blow for Sofia was the death from illness of her sister Anita, with whom she was specially close, on Sofia's birthday, 8th March 1998. In July 1999, she gave birth to her baby boy, Leonaldo, who she is raising alone, because the father abandoned her as soon as she got pregnant.

Sofia has an hour's walk to school every day, where she is studying the final year of primary education in the community school, about 2 kilometres from her home. Next year she will go to secondary school, which is 9.5 kilometres from where she lives. She will use a wheelchair with a special handlebar, donated by two Spanish charities.

Sofía vive con su madre Lidya Alberto, su herma-
na Anastasia, de 14 años, su hijo Leonaldo y su sobri-
no Elface, hijo de su hermano Mateus, que emigró a
Swazilandia. Sobreviven de una pequeña parcela situa-
da en el distrito de Boane, a unos 40 kilómetros de
Maputo, la capital mozambiqueña.

Los domingos asiste a misa en una de las iglesias
evangélicas locales. Después, acompaña a su madre al
cementerio para arreglar las tumbas de sus hermanas
Anita y María. Cuando necesita reparar las prótesis se
traslada a la capital. En los últimos nueve años ha teni-
do que cambiar cuatro veces de prótesis.

*Sofia lives with her mother Lidya Alberto, her sister Anastasia, who is 14, her son
Leonaldo and her nephew Elface, son of her brother Mateus who emigrated to Swaziland. They
survive on a little plot of land in Boane district, about 40 kilometres from Maputo, the capital of
Mozambique.*

*On Sundays, she goes to the religious services in one of the local Evangelical churches.
Afterwards, she accompanies her mother to the cemetery, where they tidy the graves of her sisters
Anita and Maria. When she needs to have the prosthetic limbs repaired, she goes to the capital city.
She has had to have the limbs changed four times over the past nine years.*

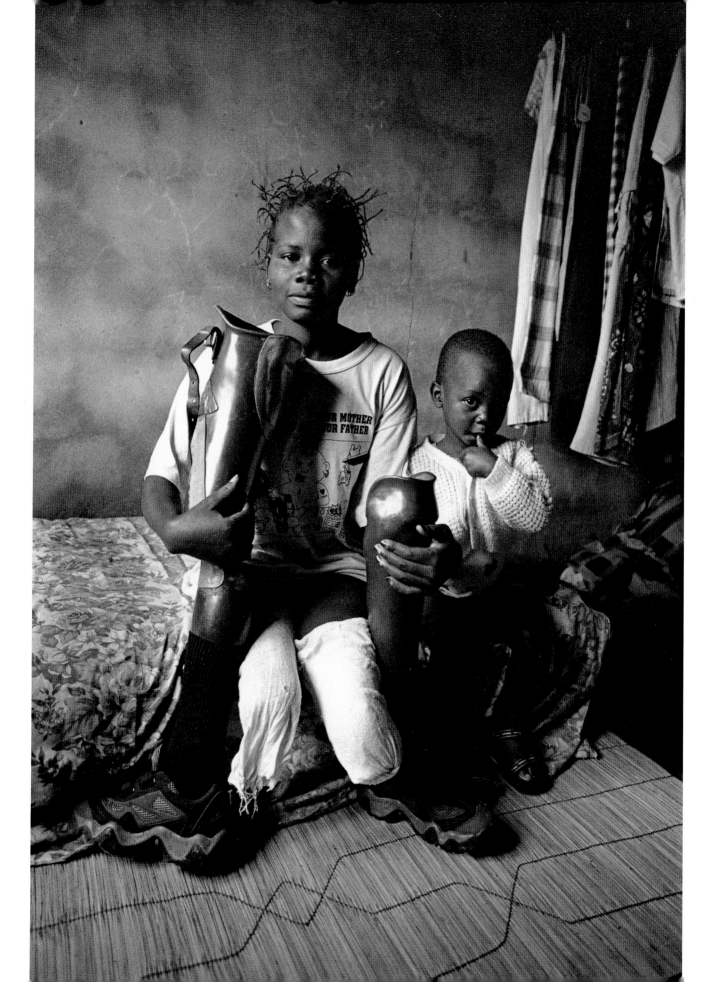

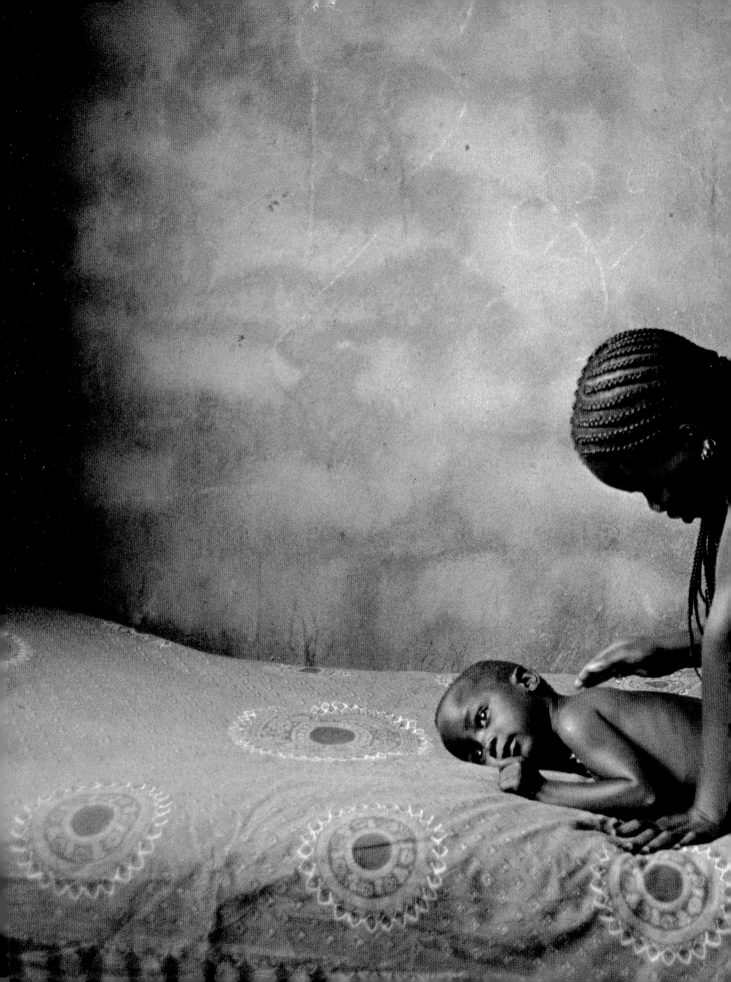

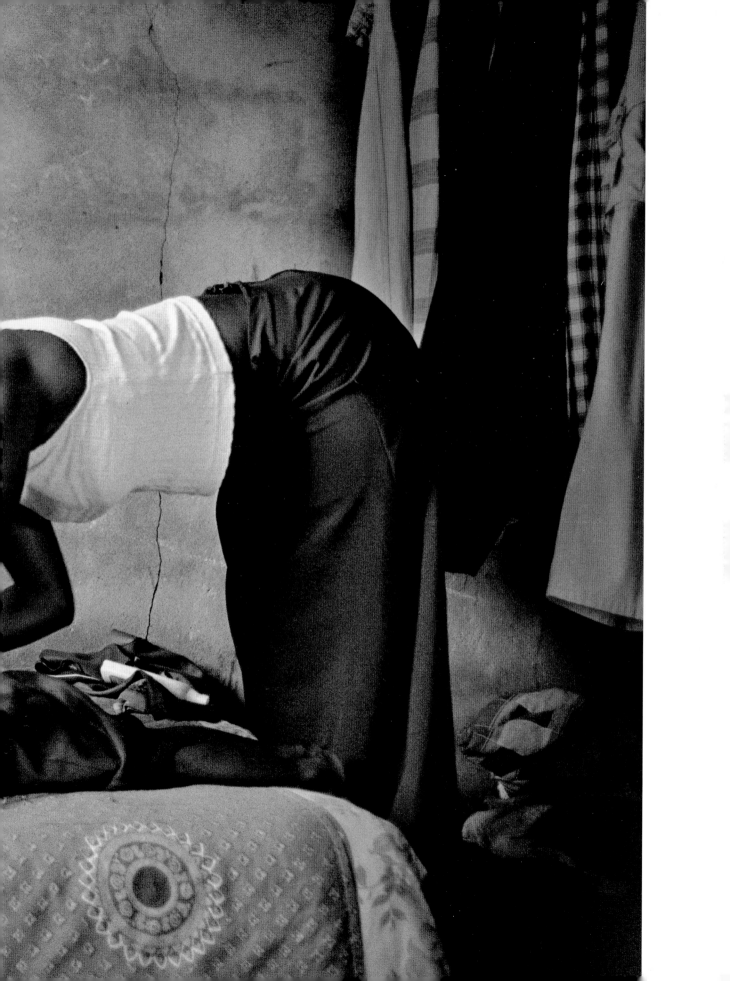

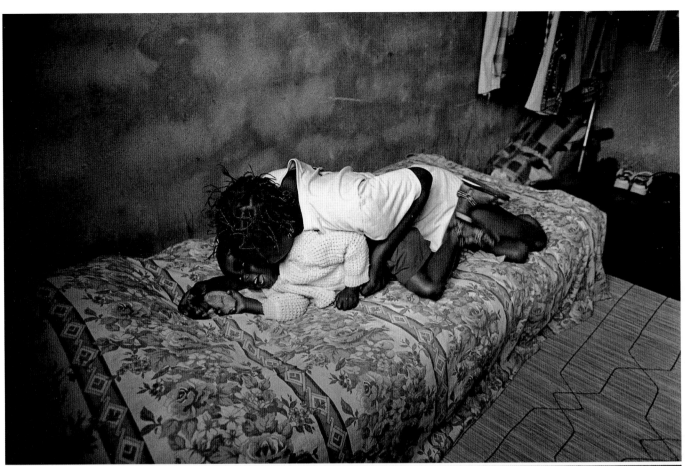
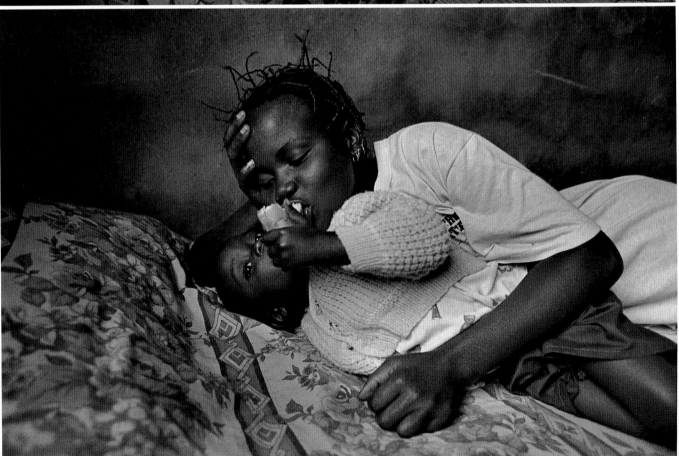

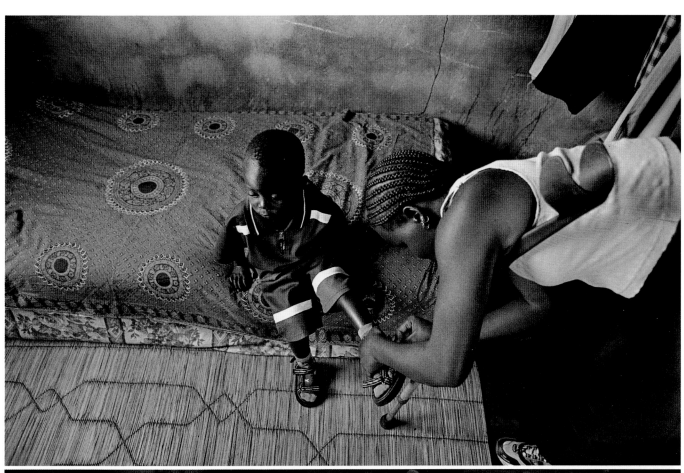

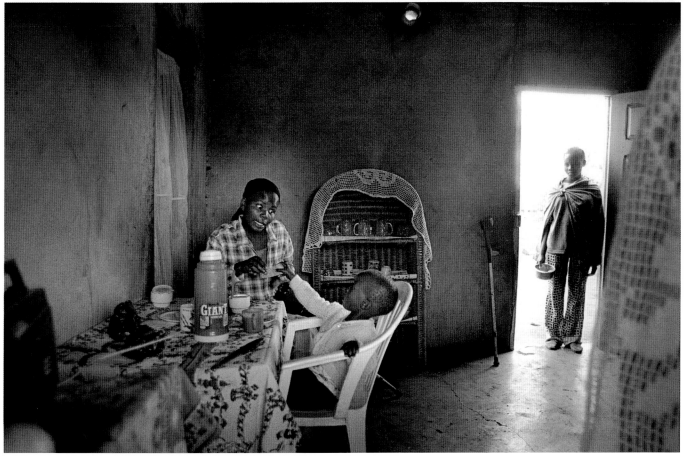

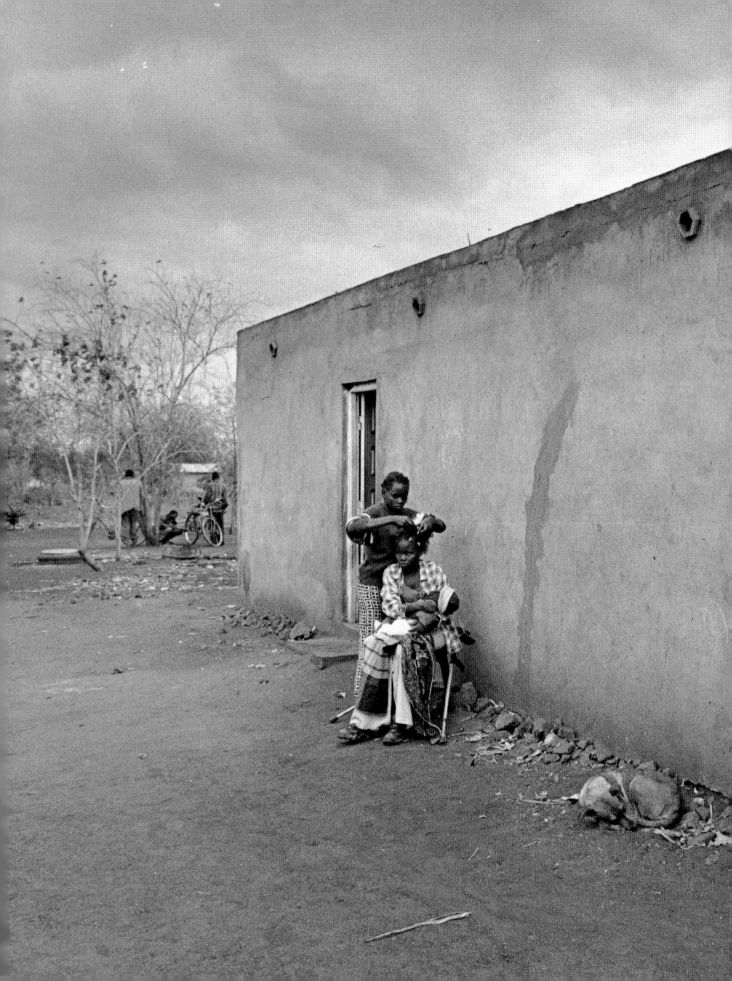

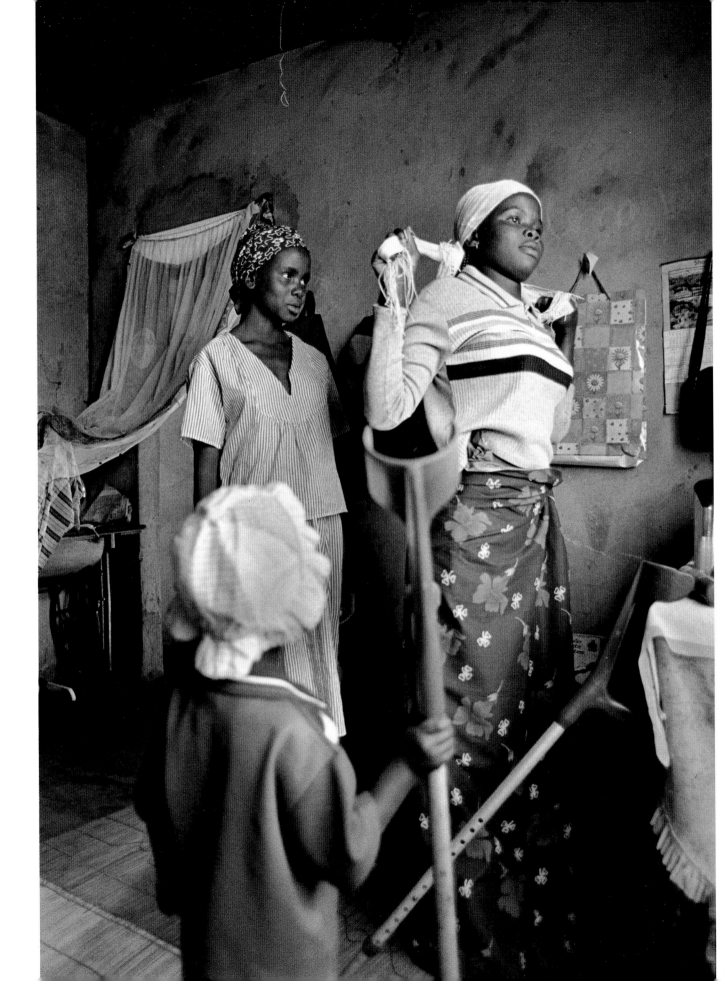

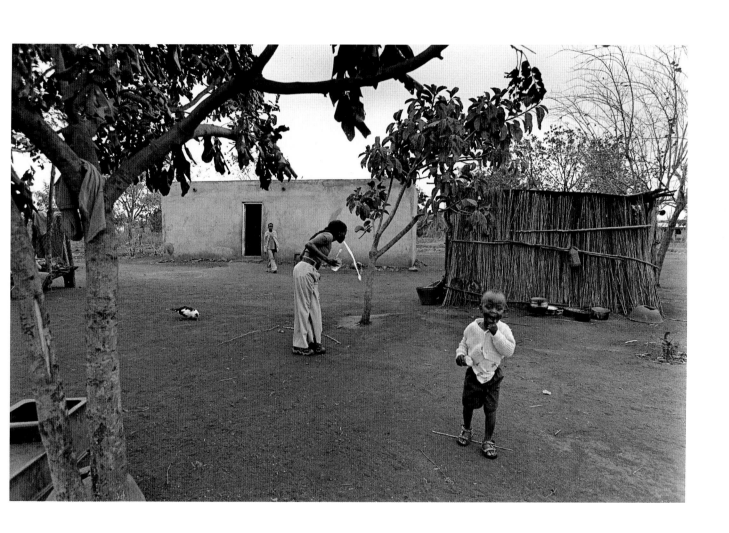

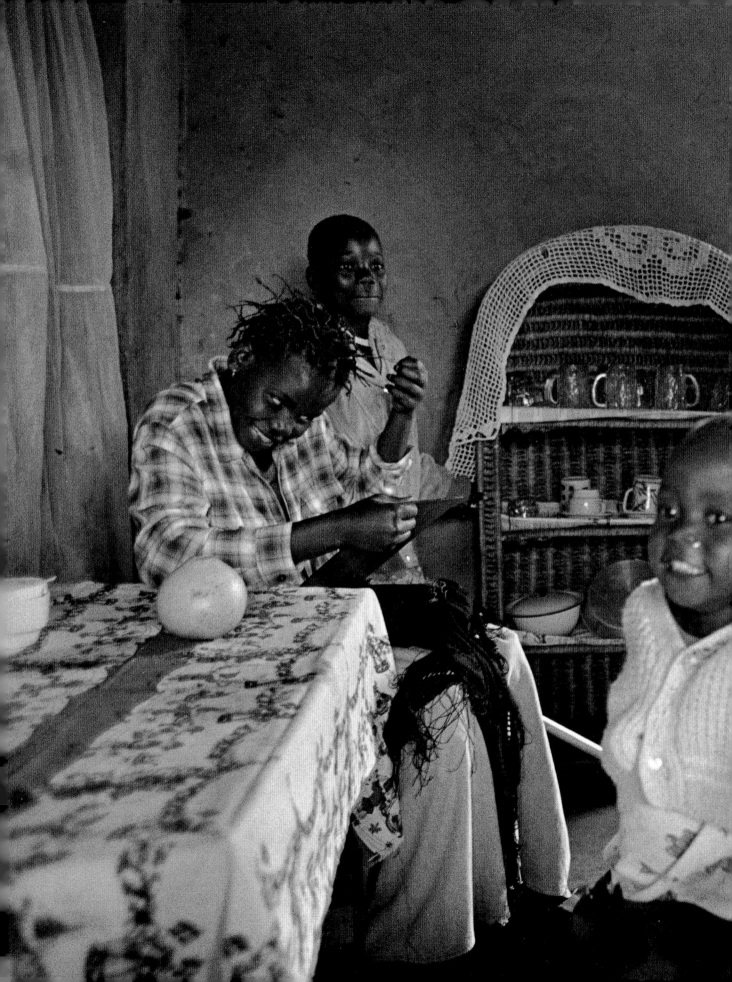

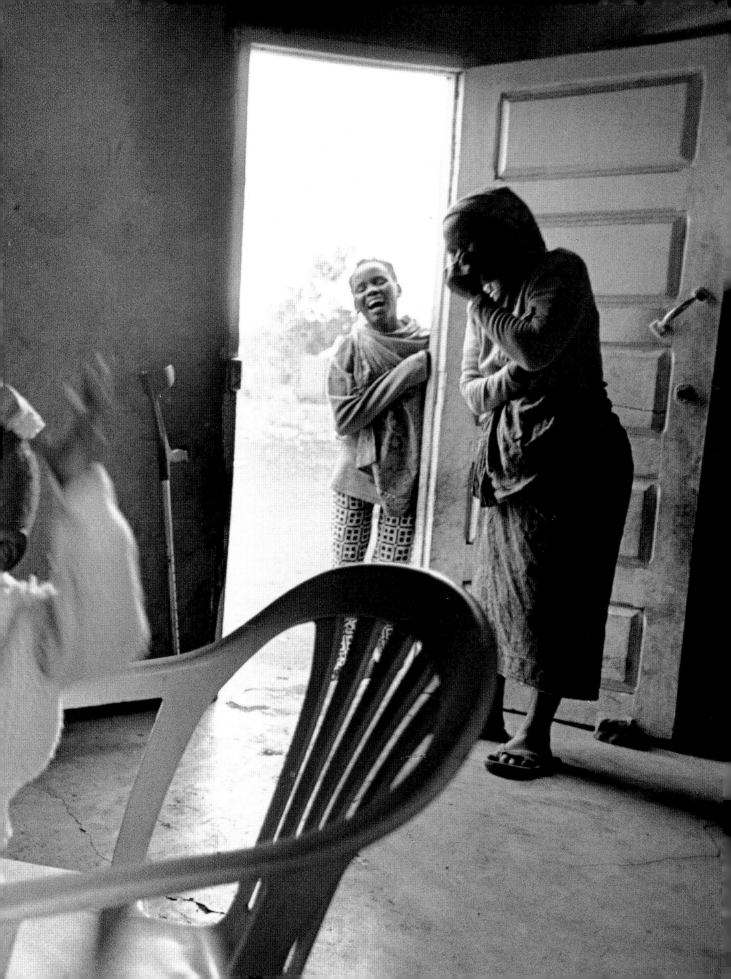

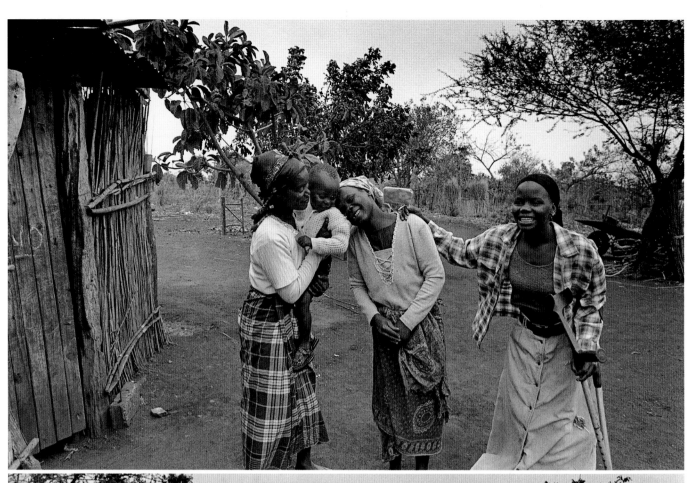
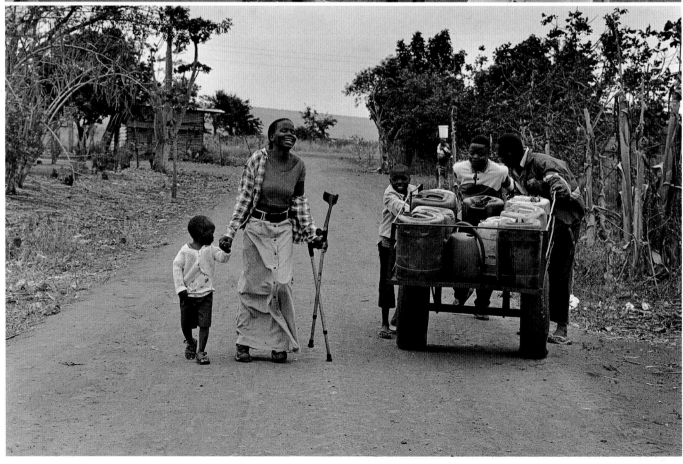

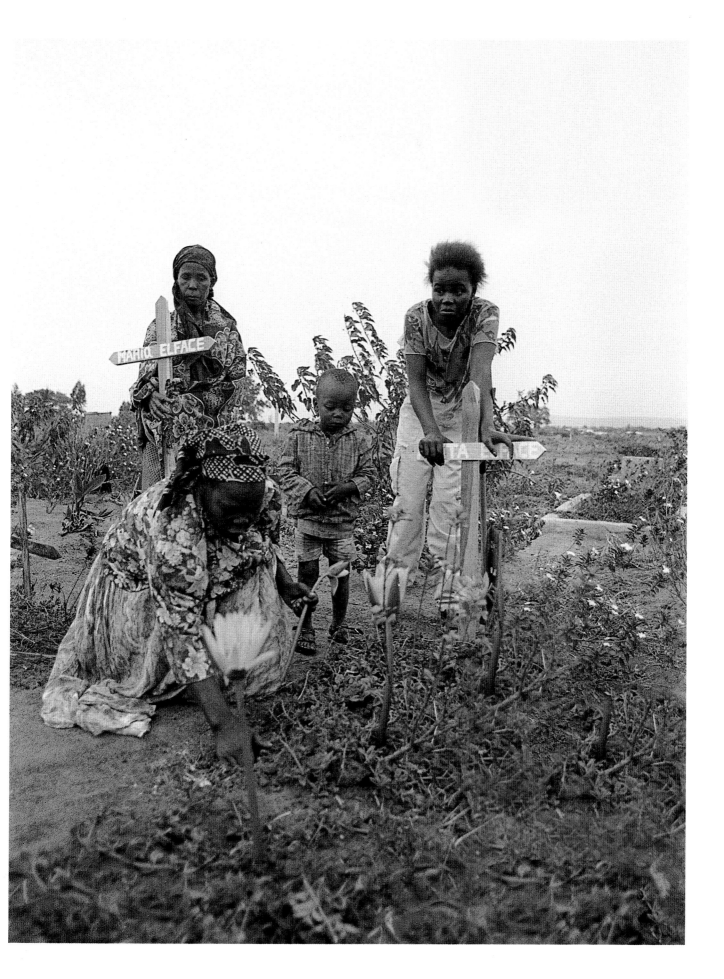

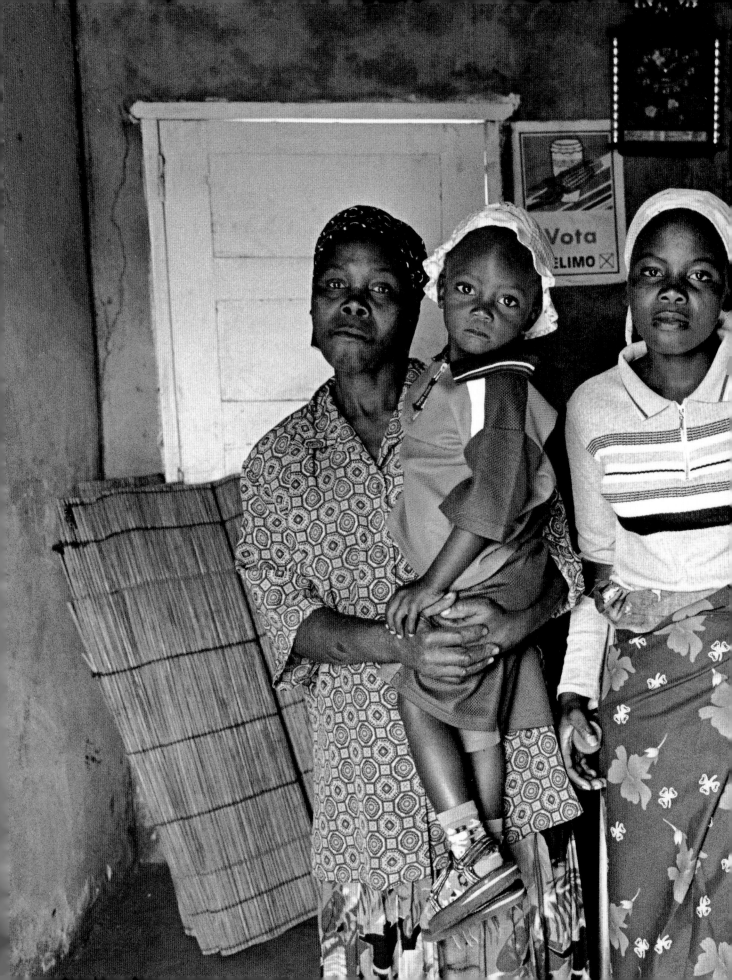

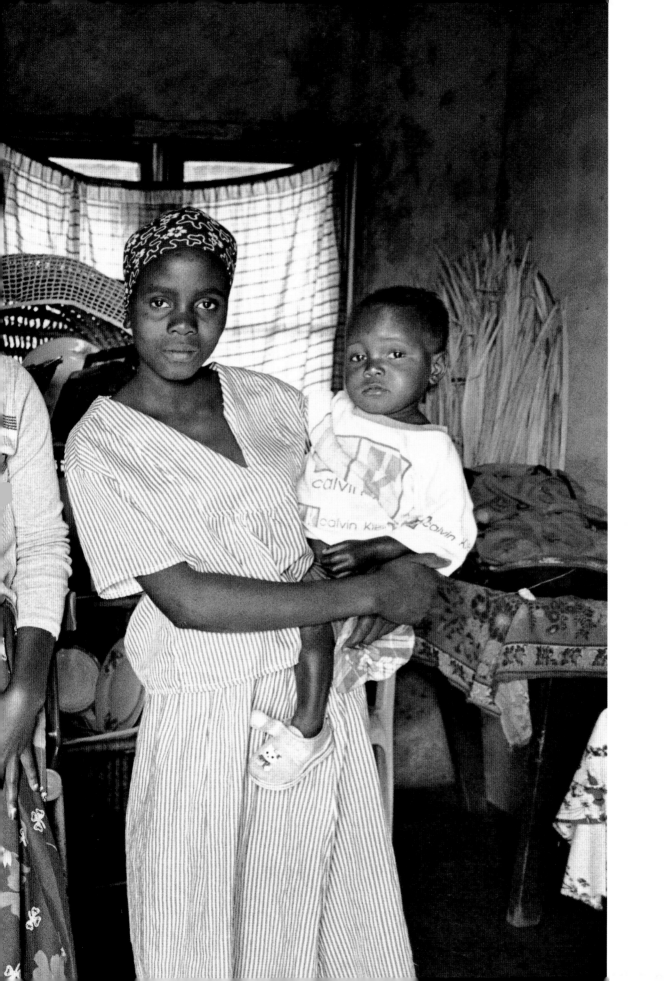

Gervasio Sánchez

Nacido en Córdoba (España) en agosto de 1959, Gervasio Sánchez se licenció en 1984 en periodismo. Desde entonces ha trabajado como periodista independiente en más de dos decenas de conflictos armados para diferentes diarios como *Heraldo de Aragón*, *El País* y *La Vanguardia*. También colabora con la agencia Cover, la revista *Tiempo*, la cadena Ser y la BBC.

En diciembre de 1994 se publicó su libro fotográfico *El Cerco de Sarajevo*, resumen de su trabajo en la sitiada capital bosnia entre junio de 1992 y marzo de 1994.

En octubre de 1995 inició un proyecto fotográfico sobre el impacto de las minas antipersona contra las poblaciones civiles en los países más afectados del mundo, entre ellos Afganistán, Angola y Camboya, que concluyó en noviembre de 1997 con un nuevo libro titulado *Vidas Minadas* (en colaboración con las ONGs Intermón, Manos Unidas, Médicos Sin Fronteras, y Editorial Blume).

En noviembre de 1999 publicó su libro fotográfico *Kosovo. Crónica de la deportación* (Blume) y en febrero de 2000 apareció *Niños de la guerra* (Blume), resumen de su trabajo en la última década en más de una quincena de conflictos armados. En 2001, Blume publicó su obra *La Caravana de la Muerte, Las víctimas de Pinochet*.

La Asociación de la Prensa de Aragón le otorgó por unanimidad en 1993 el Premio al Mejor Periodista del Año por su cobertura de la guerra de Bosnia. El Club Internacional de Prensa de Madrid le concedió en 1994 el Premio al Mejor Trabajo Gráfico del Año por la cobertura de la guerra de Bosnia.

En 1995 le fue concedido el Premio de Andalucía de Cultura en la modalidad de Fotografía. El jurado destacó en el acta su «visión generosa y humanitaria, comprometida con el máximo rigor periodístico, ejemplo de nuevo periodismo que debe impulsar a las futuras generaciones de fotógrafos».

En junio de 1996 le fue concedido el premio Cirilo Rodríguez, el más prestigioso del Estado español para periodistas que ejercen su labor en el extranjero como enviados especiales o corresponsales permanentes.

En diciembre de 1997, la Asociación Pro Derechos Humanos de España le concedió el Premio de Derechos Humanos de Periodismo por su libro *Vidas Minadas* y su trayectoria profesional.

El excelentísimo Ayuntamiento de Zaragoza acordó en septiembre de 1998 concederle el título de Hijo Adoptivo en «reconocimiento a los excepcionales méritos contraídos en el ejercicio de su actividad como fotógrafo en la que ha destacado por su sensibilidad social y su denuncia de los horrores de la guerra».

La Organización de las Naciones Unidas para la Educación, la Ciencia y la Cultura (UNESCO) le nombró «Enviado Especial de la Unesco por la Paz» durante la celebración del 50 aniversario de la Declaración Universal de los Derechos Humanos en diciembre de 1998 por «el extraordinario testimonio que ofrece mediante la fotografía del calvario que padecen las víctimas de las minas antipersona y por su infatigable promoción de una cultura de la paz».

En julio de 2001 la Diputación Provincial de Zaragoza le concedió la Medalla de Oro de Santa Isabel de Portugal por «su trayectoria periodística y su compromiso a favor de las víctimas de la guerra».

Born in Córdoba (Spain) in August 1959, Gervasio Sánchez achieved his degree in Journalism in 1984. Since then he has worked as a freelance reporter in over two dozen armed conflicts, for different newspapers, such as the Heraldo de Aragón, El País *and* La Vanguardia. *He also contributes to Cover agency,* Tiempo *magazine, the Cadena Ser radio station and the BBC.*

His photographic book El Cerco de Sarajevo *(The Siege of Sarajevo) was published in December 1994, summarising his work in the beseiged Bosnian capital between June 1992 and March 1994.*

In October 1995, he began a photographic project on the impact of antipersonnel mines on the civilian populations in the countries around the world that had been most affected, including Afghanistan, Angola and Cambodia. The work was concluded in November 1997, with the publication of a new book, called Vidas Minadas *(Mined Lives), in collaboration with the NGOs Intermón, Manos Unidas, Médicos Sin Fronteras and the publisher Editorial Blume.*

His photographic book Kosovo. Crónica de la deportación *(Kosovo. Chronicle of Deportation) was published by Blume in November 1999, and* Niños de la Guerra *(Children of War), a collection of his work in the last decade in over fifteen armed conflicts, appeared in February 2000 (also in Blume). In February 2001, Blume published* La Caravana de la Muerte, Las víctimas de Pinochet *(The Death Caravan, Pinochet's Victims.)*

The Asociación de Prensa de Aragón (Press Association of Aragón) gave him the award for Best Journalist of the Year (Mejor Periodista del Año) in 1993, in a unanimous decision, for his work in the Bosnian war. In 1994, he won the Premio al Mejor Trabajo Gráfico del Año (Award for the Best Photographic Work of the Year) for his coverage of the war in Bosnia.

In 1995, he was awarded the Premio de Andalucía de Cultura (Andalucia Culture Award) in the photographic section. The jury made special mention of his "generous, humanitarian vision, committed to the highest journalistic integrity, an example of new journalism that should inspire future generations of photographers."

In June 1996, he won the Cirilo Rodríguez prize, the most prestigious Spanish award for reporters who work abroad as special or permanent correspondents.

In December 1997, the Asociación Pro Derechos Humanos (Pro-Human Rights Association) in Spain awarded him the Human Rights Award for Journalism, for his book Vidas Minadas *and for his personal committment.*

The Ayuntamiento de Zaragoza (Zaragoza City Hall) designated him Adoptive Son of the city of Zaragoza in September 1998, "in recognition of the exceptional merits gained in his work as a photographer, in which his social sensitivity and his efforts to denounce the horrors of war stand out."

The United Nations Education, Science and Culture Organisation (UNESCO) designated him as a UNESCO Artist for Peace during the celebrations of the 50th Anniversary of the Universal Declaration of Human Rights, in December 1998, for "the extraordinary testimony he offers through his photographs of the suffering undergone by the victims of anti-personnel mines and for his untiring support of culture for peace."

In July 2001, the Diputación Provincial in Zaragoza (Zaragoza provincial government) awarded him the Medalla de Oro de Santa Isabel de Portugal (Gold Medal of Saint Isabella of Portugal) for "his career in journalism and his dedication to the support of victims of war."

Intermón Oxfam

Desde 1956 INTERMÓN OXFAM, ONG dedicada a la cooperación para el desarrollo y a la ayuda humanitaria, trabaja junto a las personas de los países desfavorecidos en América Latina, África y Asia, para que logren ejercer su derecho a una vida digna y salgan adelante por sí mismas. Gestionamos más de 600 proyectos de cooperación en más de 30 países.

Desde 1997 trabajamos junto con los otros 11 miembros de OXFAM INTERNACIONAL, sumando esfuerzos para conseguir mayor eficacia. Compartimos objetivos y una misma creencia: todo hombre, mujer, niño y niña del mundo tiene derecho a vivir dignamente y a decidir sobre su propia vida. Como grupo contamos con el apoyo de 1,5 millones de socios, socias y personas colaboradoras, y cooperamos en 107 países.

Nuestro trabajo

Nuestra labor se orienta en lograr el cumplimiento de los derechos sociales y económicos de las personas y poblaciones más desfavorecidas, tales como los derechos a unos medios de vida sostenibles; educación y salud, a la vida y a la seguridad en situaciones de emergencia, a la participación social y política y la propia identidad de género y diversidad.
Para esto:
- impulsamos proyectos de desarrollo en países de África, América y Asia, a través de organizaciones locales.
- actuamos con celeridad ante situaciones de emergencia para salvar vidas y sentar las bases para reducir la vulnerabilidad en lo posterior.
- promovemos campañas de influencia social y política para generar cambios a favor de las poblaciones empobrecidas y fomentar valores y actitudes positivas a favor de un mundo solidario.
- fomentamos el comercio justo, apoyando el intercambio equitativo entre el norte y el sur.

Una suma de esfuerzos

Para lograr todos estos objetivos, durante el ejercicio 2000-2001 gestionamos 6.706 millones de pesetas (40,3 millones de euros) gracias a las aportaciones económicas de más de 160.000 socios, socias, personas colaboradoras e instituciones públicas y privadas.

Formando alianzas

INTERMÓN OXFAM es miembro consultivo de las Naciones Unidas, de EUROSTEP –red que agrupa a 23 de las principales ONGD de 15 países de Europa–, de IFAT (Federación Internacional de Comercio Justo), EFTA (European Fair Trade Association) y pertenece a la Coordinadora española de ONGD, así como a diversas federaciones autonómicas.

Todo esto es posible gracias a las miles de personas que creen y confían en el trabajo que INTERMÓN OXFAM realiza a través de su equipo operativo, los departamentos centrales, las nueve sedes territoriales y los 30 comités en España y Andorra, así como las representaciones en América Latina, África y Asia (India), a través de las cuales se gestionan todos los proyectos.

Para más información, contacte con 902 330 331 · www.IntermonOxfam.org

Since 1956, INTERMON OXFAM, a charity for co-operation in development and humanitarian aid, has been working with people in the most underprivileged countries in Latin America, Africa and Asia, with the aim of helping them exercise their rights to a decent life and be able to move forward on their own. We administer more than 600 co-operation projects in over 30 countries.

Since 1997, we work together with the other 11 members of OFXAM INTERNATIONAL, to increase the effectiveness of our joint efforts. We share the same objectives and belief: every man, woman and child in the world has the right to live a decent life and to take decisions about his or her own life. As a group, we have the support of 1.5 million members and contributors, and we work in 107 countries.

Our work

*Our work is aimed at achieving the fulfilment of social and economic rights for the most underprivileged people and populations, such as the rights to sustainable means of life, education and health, to life itself and safety in emergency situations, to social and political participation, and to one's own identity, sex and diversity.
To this end:*
- *We promote development projects in countries in Africa, America and Asia, through local organisations.*
- *We act quickly in emergency situations to save lives and provide guidelines to reduce risk later on.*
- *We create social and political awareness campaigns to generate change in favour of the poorest populations and to encourage positive values and attitudes towards a committed world.*
- *We promote Fair Trade, with support for equitable exchange between the North and the South.*

The sum of our efforts

In order to achieve these aims, we have administered 6.706 million pesetas (40.3 million euros) in 2000-2001, thanks to the financial contributions from over 160,000 members, contributors and public and private organisations.

Creating alliances

INTERMON OXFAM is a consulting member of the United Nations, of EUROSTEP –a network of 23 of the principal charities in 15 European countries–, of IFAT (International Fair Trade Federation), and it belongs to the Spanish charity co-ordinating body, ONGD, as well as various local federations.

All this is possible thanks to the thousands of people who believe and trust in the work carried out by INTERMON OXFAM through its operating team, central departments, territorial offices and 30 committees in Spain and Andorra, as well as the representations in Latin America, Africa and Asia (India), who administer all the projects that we carry out.

For further information call: 902 330 331 (in Spain) or go online to: www.IntermonOxfam.org

Médicos Sin Fronteras

Médicos Sin Fronteras (MSF) es una organización médica de acción humanitaria que aporta su ayuda a las víctimas de catástrofes de origen natural o humano y de conflictos armados, sin ninguna discriminación de raza, sexo, religión, filosofía o política.

Más de treinta años trabajando

MSF es una organización privada, independiente y aconfesional que tiene su origen en el inconformismo de dos grupos de médicos que coincidieron en Francia a principios de los años setenta. Unos habían sido testigos del genocidio de la minoría ibo durante la guerra de secesión de Biafra (Nigeria, 1968) y se sentían frustrados ante la obligación de guardar silencio que les exigía la organización con la que trabajaban. Otros acababan de comprobar sobre el terreno la descoordinación y la falta de medios con que se atendió a las víctimas de las inundaciones que en 1970 asolaron Pakistán Oriental (actual Bangladesh). Pronto coincidieron en que la acción humanitaria debía adaptarse a los nuevos tiempos.

La acción humanitaria

La acción humanitaria es un gesto de una sociedad civil a otra que se caracteriza por dos elementos inseparables y complementarios entre sí: la asistencia y la protección.

Trabajamos con las personas víctimas de la exclusión, y es esta proximidad la que permite realizar un acto de solidaridad sobre la base de los principios humanitarios de humanidad, independencia, imparcialidad, neutralidad y voluntariado. Para garantizar el carácter humanitario de la asistencia, MSF considera imprescindible que se den tres condiciones básicas: la libertad de acceso a las poblaciones vulnerables, la evaluación imparcial de las necesidades humanitarias de dichas poblaciones y la supervisión y control de la cadena de asistencia.

Áreas de actuación

MSF actúa en conflictos armados, catástrofes naturales y de origen humano, campos de refugiados y desplazados, epidemias, hambrunas, programas a medio plazo y situaciones de exclusión. Consideramos que la sensibilización de la sociedad es parte integrante de nuestro trabajo, con la doble finalidad de rescatar del olvido a las poblaciones en situación precaria y cambiar actitudes. Para ello, MSF testimonia sobre desplazamientos forzados, violaciones masivas de derechos humanos, genocidios, crímenes de guerra, y emprende campañas de sensibilización y presión para promover cambios en la legislación vigente e influir en los procesos de toma de decisiones.

MSF cuenta actualmente con sedes en 18 países, está presente en más de 80 y envía cada año a los diferentes escenarios de crisis a 3.000 profesionales de 45 nacionalidades que colaboran con unos 13.000 profesionales locales. Es una labor que puede llevarse a cabo gracias a más de dos millones de socios y colaboradores en todo el mundo. Ellos representan el apoyo de la sociedad civil a las actuaciones de MSF y preservan su independencia económica y de acción.

Para más información contacte con 902 250 902 · www.msf.es

Médicos Sin Fronteras (Medécins Sans Frontières, MSF) is a humanitarian medical aid agency which assists victims of man-made and natural disasters and of armed conflicts, regardless of race, sex, religion, philosophy or politics.

Over thirty years of work

MSF is a private, independent, non-religious organisation that started with two groups of non-conformist doctors who coincided in France at the beginning of the seventies. Some had witnessed the genocide of the Ibo minority population during the Biafran war of independence (Nigeria 1968) and they were frustrated by the silence imposed on them by the organisation in which they then worked. Others had just experienced in situ the lack of co-ordination and of resources available to assist the victims of the tremendous floods in East Pakistan (now Bangladesh) in 1970. They soon agreed that humanitarian aid should be adapted to modern times.

Humanitarian aid

Humanitarian aid is a gesture from one civilian society to another civilian society, characterised by two inseparable, complementary elements: aid and protection.

We work with people who are the victims of exclusion, and it is this proximity which enables us to act in solidarity with them based on the humanitarian principles of humanity, impartiality, neutrality and voluntary work. In order to guarantee the humanitarian aspect of its aid, MSF considers the following three conditions to be vital: free access to vulnerable populations, impartial evaluations of the humanitarian needs of said populations, and the supervision and control of the whole aid process.

Areas in which we work

MSF offers aid in armed conflicts, natural and man-made disasters, refugee camps, epidemics, starvation, mid-term programmes and exclusion situations. We believe that raising awareness of these situations in society is an integral part of our work, and has the double purpose of shedding light on populations in precarious situations and of changing attitudes. To this end, MSF informs the world about forced evictions of populations, massive violations of human rights, genocides, war crimes; and it campaigns to raise awareness and pressure to change current laws and to influence decision-taking.

MSF currently has offices in 18 countries, it is present in over 80 countries and each year it sends, to different crises, 3000 professional aid workers from 45 different nationalities, who collaborate with 13,000 local professional workers. This work is carried out thanks to the over 2 million members and collaborators worldwide. They represent civilian society's support of MSF's aid activities and maintain the organisation's financial and aid independence.

For futher information call: 902 250 902 (in Spain) or go online to: www.msf.es